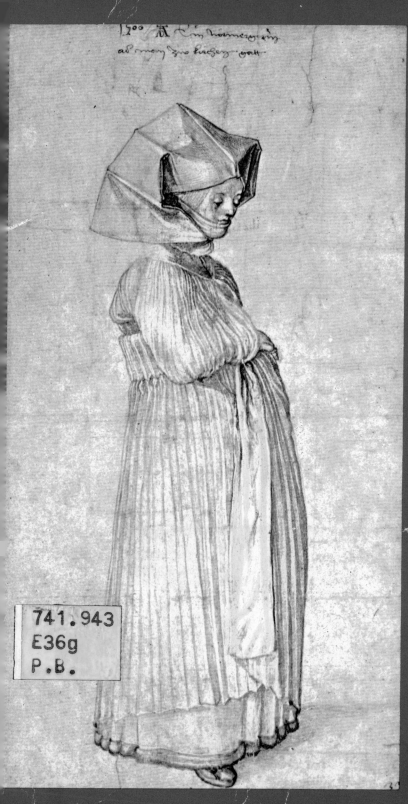

$4.95

GERMAN DRAWINGS

FROM THE 16TH CENTURY TO THE EXPRESSIONISTS

Colin T. Eisler

DRAWINGS OF THE MASTERS

GERMAN DRAWINGS

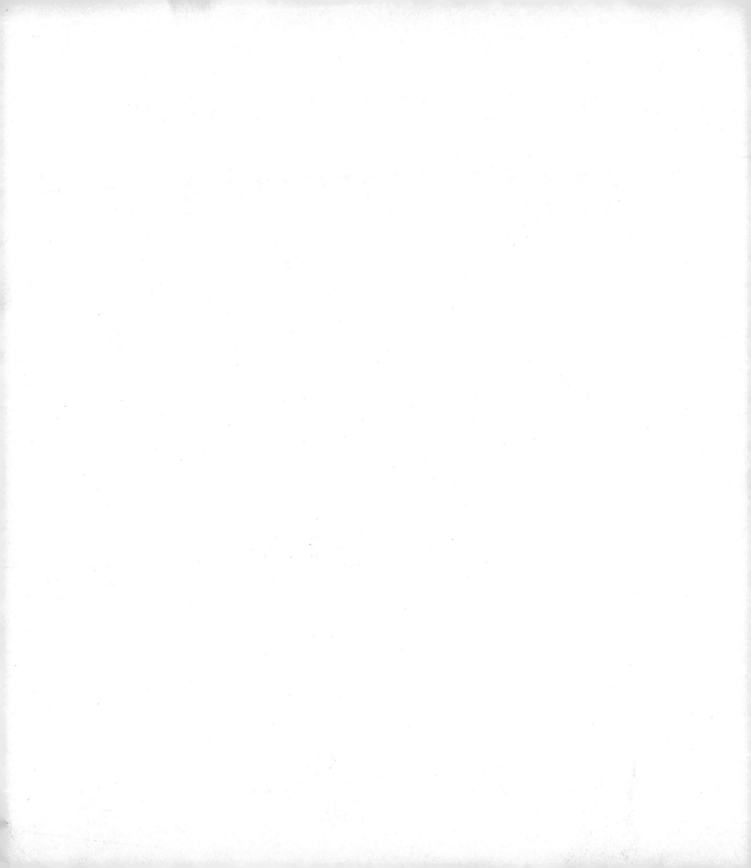

DRAWINGS OF THE MASTERS
GERMAN DRAWINGS

From the 16th Century to the Expressionists

Text by Colin T. Eisler

LITTLE, BROWN AND COMPANY BOSTON · TORONTO

A

LIBRARY OF CONGRESS CATALOGING IN PUBLICATION DATA

Eisler, Colin T
 German drawings from the 16th century to the expres-
sionists.

 Reprint of the ed. published by Shorewood Publishers,
New York, in series: Drawings of the masters.
 Bibliography: p.
 1. Drawings, German. I. Title. II. Series.
[NC249.E35 1975] 741.9'43 75-11516
ISBN 0-316-22520-7

Published simultaneously in Canada
by Little, Brown & Company (Canada) Limited

PRINTED IN THE UNITED STATES OF AMERICA

Contents

GERMAN DRAWINGS

Line, at once so descriptive and so generalizing, is the primary vehicle of art. In the North, it has often been the ultimate expression as well. Equally concerned with the profoundly abstract and the acutely specific, the German-speaking world has always been drawn to the graphic arts. Involved with extremes, with the drastic rendering of emotion, line is the eternal cornerstone of German art, for it is line, rather than color, which initiates expression. The balance between both, resulting in classical form, was rarely desired in the North. Acutely concerned with externalizing the vocabulary of feeling, it is the realm of line that is consistently the most powerful element in German art.

With its traditional emphasis on craftsmanship, technical versatility and design, the region between the Rhine and the Danube has always made much use of the preparatory drawing. Artist and artisan, so often fused, utilized many "working" drawings—renderings of projects for execution on panel, in metal or stone, for a thousand-and-one objects of sacred and profane use.

In the late fourteenth and early fifteenth centuries, Northern art was in the manner of the so-called International style, where forms were presented in lyrical, gently-curving passages, like those employed by the Austrian artist in his depiction of *Saint Margaret*. The same sinuous, elegantly-spiralling contours which twist the dragon's tail, pleat the saint's robes. This chivalric lineage of the late Middle Ages was soon to encounter a new, incisively realistic approach, originating in the Netherlands. Brisk and direct, the fresh current was as closely related to the recently-discovered art of print-making by metal engraving as the earlier, more gracious style had been to that of the woodcuts, whose broad, harmonious lines flowed like the leading of a stained-glass window.

It was in German-speaking lands that the major innovations in print-making took place. The Master E. S., among the first identifiable draughtsmen of the fifteenth century, was a pioneer among engravers. His masterly

rendering of the *Baptism of Christ* used thousands of very short, almost dot-like parallel lines to create a sense of plasticity—a device that also distinguishes his engravings. A certain witty objectivity characterizes the art of Master E. S. and his followers. Delighting in the grotesque, in rapid shifts between the elevated and the debased, the real and the ideal, these artists abandoned the protective but now stagnant conventions of the International style, casting an unblinking eye at the world around them, rendering it with unparalleled vigor and *joie de vivre*.

Active after the middle of the century, the Master of the Housebook continued the art of Master E. S. Alternately infused by compassion or with silent laughter, the Master of the Housebook's art was tempered by profound humanity. His drawings and engravings anticipated the art of that master of the human comedy, Rembrandt, who, like these masters of the fifteenth century also came from the region of the lower Rhine valley. Drawings closely related to the paintings of Stephan Lochner and Konrad Witz show how these artists concentrated their energies in establishing and defining form in the most immediate and tangible manner. Lochner's *Virgin and Child* retained a lingering sweetness of the International style. A drawing in the style of Witz showed a new concern with the creation of space and the texture of experience, exemplified by the dazzling illusionism of the Christ Child's reflection in a wash basin and the unabashed domesticity of the Virgin with a diaper.

The last flowering of the International style in Germany can be seen in the beautiful drawings of Martin Schongauer. As prolific a print-maker as Master E. S., his engravings and many surviving drawings present a *corpus* of the artistic vocabulary of the first two-thirds of the fifteenth century. Schongauer's *oeuvre* draws together the manifold achievements of his great Flemish predecessors as comprehensively as did Marcantonio those of the Roman High Renaissance. Original as well as derivative, Schongauer could infuse line with a sense of tension and excitement. His *Angel Gabriel,* a preparatory

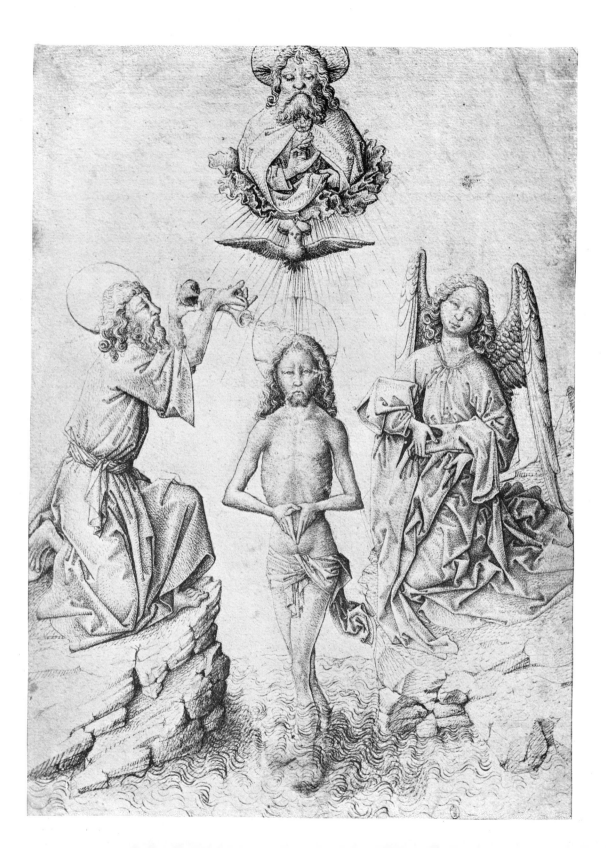

13

study for an engraving, betrays a complexity of emotion and an "art-for-art's-sake" fascination in the almost Leonardesque scrutiny of the angel's curls, pointing to the mannered and involved currents of subsequent German art.

In the last quarter of the fifteenth century most draughtsmen continued Schongauer's concern with the art of the Netherlands, but in a rather lack-luster fashion, uninspired recapitulations of the art of Rogier van der Weyden. Or, they lost themselves in a jungle of late-medieval ornament, like that of Wolgemut's *God the Father Enthroned* of 1490. At its best, this renewed interest in abstract design was to be an important factor in the fifteenth-century "Gothic Revival," but in the hands of Wolgemut and his coarse, archaizing contemporaries it is sadly lacking interest. Already dimly aware of the achievements of the Italian Renaissance, Wolgemut's framing columns and cavorting babes resemble a Gothicized bacchic sarcophagus.

It was in this already confused and somewhat stale environment that the incredibly gifted young Albrecht Dürer was trained. Apprenticed to Wolgemut at the age of fifteen, he had already mastered the art of ornament in the workshop of his goldsmith father. As industrious as he was talented, Dürer's art is a marvel of zealous scrutiny, inspired craftsmanship and erudition. Supreme master of all the known graphic techniques of the time, Dürer's encyclopedic grasp encompassed drawing—in white and other colors on toned paper, brush, pen-and-ink, water color and pastel, charcoal and lead—and painting in oil and tempera on vellum, paper, panel and canvas. A master of all print-making processes, he worked or directed work in the media of wood-cuts, engravings and even the recently-discovered etching technique. His capacity for consistent excellence in concept and execution make Dürer an artistic phenomenon, author of an *oeuvre* unparalleled for quality of quantity.

Impatient with the arid milieu of Nuremberg, whose real interests were devoted to the new skills of typography and book-manufacture, the young Dürer hoped to learn from the old Martin Schongauer, but arrived in Colmar

just after that master's death. The disappointed young artist went on to Italy, completing his early training with the traditional *Wanderjahr*. Making the first of his two journeys to Italy early in his career, Dürer was overcome by the opulence of Venice, the beauty of Bellini's art and the classical authority of Mantegna. Much of his life was devoted to trying to straddle the divide between Germany and Italy, producing an often unstable fusion of the Gothic and the Renaissance.

It is in his drawings and prints that the happiest aspects of Dürer's manifold talents assert themselves, rather than in his often over-wrought paintings. He made thousands of preparatory portrait, plant, animal and landscape studies, as well as countless others for stained-glass, pageantry, and for projects in typography, metal, wood and stone. Throughout his life the artist also drew many completely independent works for his personal delectation or for that of his patrons. These drawings include landscapes made on his many journeys, quick sketches of friends, finished portrait drawings of artists and men of note. An avid diarist, many of Dürer's finest works unite the fleeting with the documentary, arresting and preserving the gestures and attitudes of his complex age.

Dürer's *Self-Portrait at the Age of Thirteen*, when still apprenticed to his goldsmith father, has all the lineaments of his style. Precise in execution, with full command of the silverpoint technique, the somewhat brooding, melancholic visage shows a personality already entirely committed to the endless pursuit of his art. A slightly later depiction, showing himself as a swaggering young gallant, is far more freely rendered, in pen and bistre, with much of the verve and directness of such an early master draughtsman as the Master of the Housebook. Dürer's ravishing water color and gouache shows the Nuremberg artist's command of an almost Impressionist vision of nature—bringing together the minutely observed and the freely experienced. Drawn on the way back from his first Italian journey of 1494, this landscape was probably exe-

cuted shortly before the beautiful *Female Nude Seen from the Back*. Here the young artist's absorption of the Italian Renaissance can be seen at once in the figure's classical proportions and coiffure—even the pose suggests an antique prototype. In no way restricted to either an Italian or Northern orientation, the young artist moved back and forth between his twin poles of creative influence, capable of rendering a *Lady of Nuremberg in Church Dress* in as precise and meticulous a manner as a late-medieval manuscript illumination.

Some of Dürer's drawings have the freedom and immediacy of the best of Northern fifteenth-century draughtsmanship, but also much of the lucidity and clarity of the Venetian art of the period. His own heritage refreshed and reappraised through the stimulus of the Italian Renaissance, Dürer was able to go on to such triumphs as the woodcut *Apocalypse* of 1498, much of whose style is already indicated in his drawings. The charcoal drawings of religious subjects show Dürer at his most passionate and direct, in subjects whose spiritual and physical force involve all his creative resources, forcing him to drop his occasionally clinical objectivity. These unusually stirring images may also have been aroused by the infinitely challenging artistry of Matthias Grünewald.

Among the most dazzling of Dürer's many highly-finished drawings are those executed in preparation for the Heller Altar, completed in 1509. The *Head of an Apostle,* in black and white on green-prepared paper, has an almost photographic intensity, an expressionistic extension of the realism of early Flemish art.

This approach is carried still further in the shatteringly objective appraisal of the ravaged features of his dying mother, drawn in 1514. Her scraggy neck and grimly-pursed toothless mouth are rendered in the same detached way that a rock formation or an uprooted tree might have been delineated. Her dimly perceiving gaze strikes almost as much pity in the beholder today as it must have in her son almost 500 years ago.

Toward the end of his life, in his late forties, Dürer executed many other intensely-observed heads, endowed with an almost surrealistic quality. The *Head of a Girl with her Eyes Closed* and *Saint Apollonia* present an uncanny fusion of the abstract and the specific which seems to be in a constant process of separation and integration. On his trip to the Netherlands, in addition to keeping a minutely-detailed diary, the artist also made many drawings in silverpoint and other media.

In the Netherlands, Dürer also drew a beautiful Passion series, using a deliberately old-fashioned horizontal format which may have been inspired by the early art of that region. These studies employed the same delicate, luminous strokes of the pen he had used earlier for the Boston *Trinity* and Frankfurt drawing, *Six Nudes*. The *Agony in the Garden,* uniting the early Northern format with an Italianate liberation, reveals the fusion of styles the artist achieved just before his death.

Director of a very large workshop, filled with associates and apprentices, Dürer's unique accomplishments were copied with varying degrees of success by generations of draughtsmen. Hans von Kulmbach's *Two Pair of Lovers* and Schaeufelein's *Last Supper* are typical of the skillful yet unpersuasive touch of most of the great master's collaborators or pupils. A more forceful and original personality than these is Hans Baldung Grien. Although a pupil of Dürer's in 1503, he created a vigorous style of his own, influenced by the art of the Danubian region and that of Grünewald. Some of his drawings reflect the somewhat weird quality of Northern humanism—borne on a tidal wave of Renaissance thought that dashed the crumbling Gothic cliffs with a resounding, and often overwhelming, impact.

Few European artists of the sixteenth and even later centuries remained untouched by Dürer's art. His prints, if not his drawings, were widely circulated in Italy and even the Near East, presenting countless eager copyists with a vast compendium of motifs and compositions for adaptation. While von

Kulmbach, Schaeufelein and others were chiefly concerned with amplifying the rich nucleus which Dürer had prepared, other associates, such as Lucas Cranach, were of a drastically different temperament. With Albrecht Altdorfer, Wolf Huber and Hirschvogel, Cranach may be numbered among the first of the Romantics. These artists of the Danubian School were endowed with a more lyrical and imaginative attitude towards nature than those of Nuremberg. Already then, in the early sixteenth century, they showed the Teutonic nostalgia for what never was. Their fondness for revivals created a faerie world from bygone styles, populated by diminutive figures of quixotic knights and whimsical virgins, lost in tangled woods, below swirling skies. These artists were pioneers in the exploration of one of the most important realms of art—that of the imaginary landscape.

Enthralled by a weird and wonderful vision of man caught and transfigured in nature, Altdorfer illuminated his many landscape drawings with galaxies and cascades of dashing, sparkling lines exploding into form. Like fireworks, his lines seem to move of their own volition, charging over the surface of the paper as they spontaneously circumscribe his shaggy, bewitched landscapes and possessed subjects. Celebrated for his exquisite prints and his Lilliputian-scale paintings, Altdorfer's drawings present the first intimations of the swirling mysteries that were to be completed in other media, using techniques so microscopic as to seem magically wrought.

Equally fanciful, but with more brutal, swaggering subjects and violently slashing strokes of calligraphy is the art of Niklaus Manuel Deutsch of Berne and Urs Graf, who was active in Basel. Disdaining the lace-like, webbed lines of Altdorfer and the Danubians, these craggy Swiss artists preferred a far more violent, erotic art. Their swashbuckling mercenaries and their lusty ladies are shown engaged in a ceaseless battle of the sexes, zestfully and derisively rendered for the delectation of both artist and audience. The initial refinements of the Danubian landscape draughtsmen appear here in seemingly "blown-

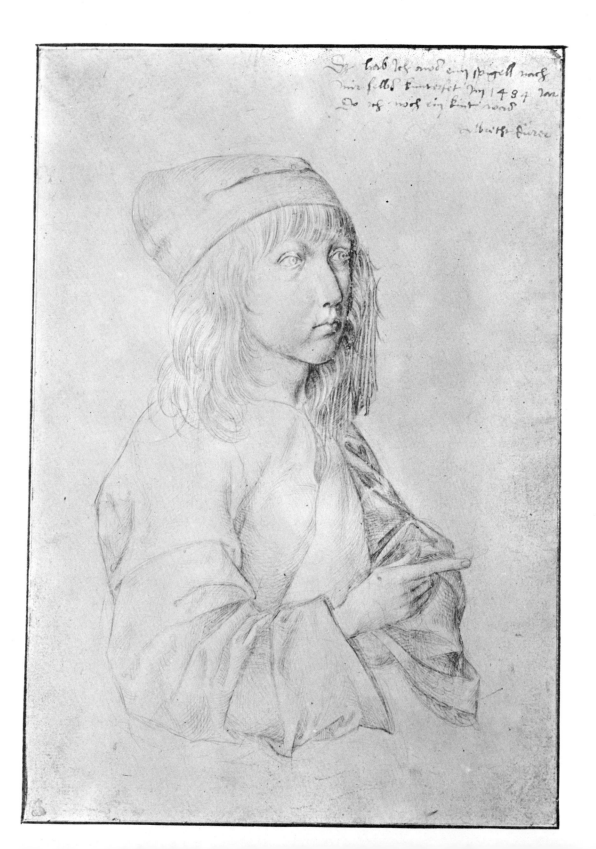

19

up" fashion, vastly enlarged, giving them a sense of gross excitement rather than an insight into a secret, private world.

The horror and inhumanity of slaughter shown in Urs Graf's *Place of Execution* seem all the more impressive due to the artist's abstract method, in which the gruesome scene appears to be rendered by an almost mechanical process, reminiscent of Oriental grass-writing or mid-twentieth-century Action Painting. It is as though a seismograph were recording the bestiality of life through its automatic registration. A goldsmith and mercenary, with a long prison record, the vitality and violence of Urs Graf are indicated by his monogram, incorporating a thrust dagger, his favorite motif and appropriate emblem for a master of decisive draughtsmanship.

Wolf Huber's landscapes have an almost arbitrary perfection, often with the shifting vistas of an unrolling Chinese landscape scroll in their ever-changing borders. The rather sudden termination of the valley views seems a deliberate statement of the artist's, contrasting the infinity of his vision of nature with the inevitable limitations of his sheet of paper. The artist's powerful brooding figure studies are close to the art of Urs Graf and Baldung Grien. His drawings of heads belong to a series of striking physiognomic explorations, a subject of constant interest in Northern art, where the dividing line between expression and expressionism is never too firmly drawn.

The greatest of German painters is certainly Matthias Grünewald. Dürer may surpass him in technical virtuosity, but Grünewald's vision, understanding and expression of a thousand strengths and subtleties place his art on a higher plane, close to that of his Italian contemporary, Leonardo da Vinci. Like the latter, he was a hydraulic engineer and architect. His early years may have been spent with the Master of the Housebook in Mainz. It is also likely that the young Grünewald may have known the art of Hans Holbein the Elder. Unlike Dürer, who received the patronage of the Emperor Maximilian and of many other leading figures of the age, Grünewald (whose actual name

was Mathis Gothart Nithardt) had fewer celebrated patrons. He served as court painter to two archbishops of Mainz, keeping an office there. His actual studio was in the small town of Seiligenstadt. Although he received very considerable fame in his lifetime and extremely important commissions, his was an isolated and lonely personality, without school, pupil, or even assistant. While Dürer was certainly impressed by Luther's views, Grünewald was more frankly and wholeheartedly behind him, and seems to have suffered accordingly. He left Catholic patronage, fleeing from Aschaffenberg to Halle, where he worked as civic engineer and died in 1527.

One of the very few German artists not to have had any interest in printmaking, Grünewald's known drawings are almost all studies for paintings—entirely devoted to establishing form in light just before its translation into color. Only thirty-six drawings survive that are unquestionably attributed to his hand. Most of these are drawn on a warm-toned, yellow or yellow-brown prepared paper with black chalk, sometimes heightened with brushed-on white or black India ink.

Like all works of genius, Grünewald's drawings defy pinpoint categorization. His mystical approach may owe something to the Danubian School; his extreme delicacy of technique could stem in part from Hans Holbein the Elder and from North Italian sources. It is Grünewald's unique feat that no individual line seems to define the sitter in his portraits—all the myriad touches of black flow together, creating a whole ineffably greater than the sum of all its parts—the most inspired realism in Northern portrait drawing since Jan van Eyck's depiction of Cardinal Albergati. Equally brilliant and even more enigmatic is the Louvre *Portrait of a Woman,* a worthy companion of the *Mona Lisa* in the same museum. Grünewald's drawings and paintings, with their uncanny fusion of light and form anticipate the art of Correggio—he was referred to by a German art historian of the seventeenth century as "the famous German Correggio."

Grünewald's Berlin drawing of the *Virgin Annunciate* was a preparatory study for Grünewald's greatest work, the *Isenheim Altar,* commissioned shortly after 1505 and probably completed by 1516. The Annunciation painting has been dated circa 1511-12, making this sheet among the earliest of Grünewald's drawings. The dramatic sweep of drapery seems to have a life of its own, imbued with that sense of the spectral, so characteristic of all his art. The study of a figure whose train is supported by angels, may date about three years later and is thought to be for a *Coronation of the Virgin,* commissioned in 1514. A much more highly-finished drawing of approximately the same date shows an unidentified male saint in a forest. After the completion of the *Isenheim Altar,* Grünewald was fascinated by a new drapery style, where cascades of pleats swirl around the figure. Made of a very thin material, the complex cycles of motion within these folds recall Leonardo's studies of whirlpools and other water formations. Here the convolutions without seem to parallel the spiritual ones within.

Although the exact date of studies of *Mourning Angels* is uncertain, it could not be far removed from the time when Grünewald was painting the *Isenheim Altar.* Ageless in grief, uniting the frustrations of infancy with the despair of senescence, the drawings of these fiercely-lamenting angels define a state of emotional intensity unequalled in Northern art since that of Hugo van der Goes. The concern of genius with the "fascination of the abomination" can be seen in Grünewald's *Three Heads—the Anti-Trinity,* one of the artist's few surviving drawings with an authentic signature. On the *verso* is the *Head of a Young Woman,* executed with greater reticence than is usual for his later style, but nonetheless endowed with that diabolical intensity underlying the best of German art.

Among the finest artists working at the very end of the fifteenth century was Hans Holbein the Elder of Augsburg. Overshadowed in posterity by his son, the father was a master of realistic but sensitive draughtsmanship. In the

spell of the oblique but anxious mood of the times, both Hans Holbein the Elder and the Younger participated in the spiritual crisis of the Reformation and its equivalent in art, the Mannerist style. Father and son moved with extraordinary ease from the direct consultation of appearance in their drawings to an attenuated and agonizing approach in their paintings and design projects.

Hans Holbein the Younger's deeply emotional and imaginative art was confined to a few surviving religious paintings and to projects for goldsmiths and other craftsmen. His vast talent was largely restricted to the elegantly distilled austerity of the portrait. Forced by controversies of the period into this relatively safe harbor, he is best known for silent, contemplative pastel studies of figures active in the court, thought and commerce of England. These point to the art of Degas, not only for their brilliant use of pastel but for the intimation of their subjects' secret sorrows.

Among the few really accomplished German artists of the second half of the sixteenth century was Herman tom Ring, member of a family distinguished for its many painters. His drawing of the *Last Judgment* shows a lively understanding of the new spatial discoveries of the Italian High Renaissance, which does not submerge his Northern heritage of sharply-defined form.

One of the most gifted of all German artists was Adam Elsheimer, whose diminutive but powerful works brought a new dimension to European art at the end of the sixteenth century. He united the minuscule magic of Altdorfer with the grandeur of Tintoretto. The deftly applied, dot-like strokes of white in his landscapes show the same meticulous technique as that of his paintings; which are miniature in scale and executed on copper, porcelain-like in finish. Elsheimer's many preparatory studies for his paintings anticipated the architectonic majesty of Poussin and the humanity of Rembrandt. His figure studies in brown ink showed extraordinary liberty without losing the definition of the Oriental calligraphy they so much resemble. It was perhaps

only with Elsheimer that the relentlessly Northern obsession with the particular was completely united with the classical tradition. Dying young, in Italy, where he had spent the last ten years of his short life, Elsheimer's art continued to have a pervasive influence. This was true not only in Germany, but among Italians and Flemings. Rubens appealed to the artist's widow to let him purchase whatever he could from the works left in Elsheimer's studio at his death in 1610, aged thirty-two.

England was always hospitable to Northern European artists, well before the arrival of Hans Holbein the Younger in London, where he had been summoned by members of the German mercantile colony. The extraordinary, and often somewhat enigmatic *rapport* between England and Germany has persisted, with a few obvious interruptions, to the present. Mutual economic and political interests, with the requisite intermarriage of noble families of both countries, led to a remarkable absorption of German artists. Already well under way in the sixteenth century, it reached its peak within the next hundred years. German and Flemish sculptors, painters, print-makers and other craftsmen came to England in large numbers. Typical of their approach is the work of the Bohemian artist Wenceslaus Hollar, whose hundreds of topographical drawings and costume studies are among the chief documents of English life in the early seventeenth century. Another gifted draughtsman of the German Baroque was Johann Liss. Like Elsheimer, he spent much time in Italy, enriching his art with a new understanding of the breadth of seventeenth-century Southern painting. Arriving in Venice about a century later than Dürer, Liss, too, was deeply impressed by the luminosity of her art. Liss's few surviving drawings share the courtly gaiety of the art of Feti and the painters of Genoa. Often in red chalk, they have a quality of casual confidence pointing toward the period of the Rococo, when, for the first time since the Middle Ages, German artists found a style in which they could have absolute trust.

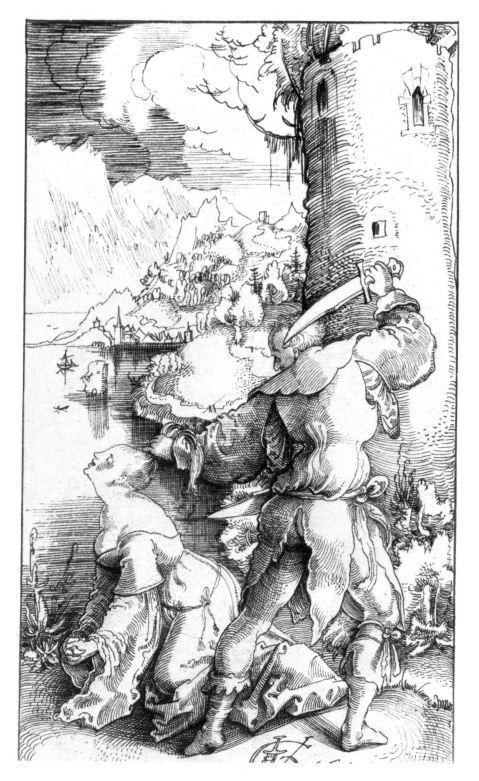

Figure 3
Urs GRAF
The Beheading of Saint Barbara
pen and India ink, 204 x 118 mm.
Basel, Kupferstichkabinett

It may well have been the doubts and conflicts of the creative process at the time of the Reformation which dampened the imaginative fires of Northern art. Until the later eighteenth century the major artistic achievements in Germany took place under Catholic patronage in the South—in Bavaria and Austria. The Rococo, like the *Jugendstil* two centuries later, was more a Northern than a Latin style, based upon abstract, expressive linear ornament rather than the classical concern with beauty as defined by the idealization of the human body. With the new enthusiasm for ornament as the major instrument of artistic communication, Germany, in the early eighteenth century, could again play a definitive role in the mainstream of European art, triumphantly exercising its heritage of flamboyantly expressionistic design.

Working in France and Northern Italy, artists and craftsmen from Germany, Switzerland and Austria, abundantly gifted in their brilliant manipulation of plaster, wood and metal, enlivened and enriched the Rococo Age with their vivacious skills. Drawings by such a master sculptor as Ignaz Günther, and those of his brother, the fresco painter Matthaus, as well as others by geniuses of illusionistic architecture—the Asam brothers—show the renewed harvest of artistic ability that had so long remained dormant, since the ruthless pruning of the Danubian woods two centuries before. Cosmas Damian Asam's *Coronation of the Virgin,* brushed in light, feathery strokes, stresses the rapidity and delicate grace so important to the new style. Its ballet-like gestures and use of a dashing, splashing line, relate to the popular art of fresco painting, with its requisite speedy execution. Maulbertsch's *Fides, Justitia and Pictura* was made for a fresco in the Archepiscopal Palace of Kremsier. It is in the late Baroque and Rococo that the notion of a bishop's palace with appropriate decorations seems especially fitting for the art of the times, uniting as it does the splendor of this world with the spirituality of the next.

In the eighteenth century, the prosperous principalities of Germany and Austria initiated an intense artistic revival. Courts like those of the Saxon

kings of Dresden not only built palace-cities which were in themselves master-pieces of urban architecture, but also plunged into a maelstrom of art patron-age and collecting. It was at this time that such great drawings and print assem-blages as those in Dresden and Vienna were formed as Northern prosperity coincided with Italian decline. Much German-speaking territory underwent intense frenchification — *Adieu* replaced *Aufwiedersehen*. So insatiable was Frederick the Great's Prussian enthusiasm for the genial art of Watteau, that made-to-measure forgeries of his works were produced in quantity for the decoration of Berlin palaces. Artists and agents were sent all over Europe to bring back masterpieces in incredible profusion.

Born in Geneva, working and traveling throughout Europe and the Near East, the flawless pastels of Liotard exemplify the seemingly effortless, cosmo-politan elegance and intimacy of the best art of the period. Also active in Dres-den, Liotard's works show a revival of the pastel, used with such consummate art by Cranach and Holbein two centuries earlier.

Toward the middle of the eighteenth century, artists moved toward a more austere, monumental style, returning to the clear statements of the early Ba-roque and the Renaissance. Rejecting the puffier agitations of the Rococo, German artists like Mengs, together with their French and Italian contempo-raries, struck out for a more lucid, clearly-defined style. Anton Raphael Mengs, an artist of international reputation, was active in Rome and a painter to the Spanish court. His draughtsmanship showed the new concern for the classical solution. Although his paintings are rather empty exercises in the monumen-tal manner, his drawings have a vital purity, pointing to those of the French David and Ingres. Angelika Kauffman, another popular painter, followed the Hanoverian monarchy to England. Her preparatory drawings show a spirited grasp of the sitter's personality that comes as a surprise to those who know only her politely-inspid finished paintings.

Impatient, possibly bored with the perpetual frivolity of the Rococo, and

the compromise between that style and the "Grand Manner" in the art of Mengs, German-speaking lands of the later-eighteenth century embraced the drastic, ascetic arts of Neo-Classicism. The tenets of this movement, at once republican and imperial, classical and contemporary, enlightened and doctrinaire, offered enormous appeal to the Graustarkian principalities and mercantile centers comprising what are now Germany and Austria. Despite their great universities and technical and scientific achievements, they felt a crushing sense of inferiority before the seemingly more unified rest of Europe. With its emphasis on the profile, linear purity and the clearly delineated form, the Neo-Classical offered irresistible attractions to a people whose cultural leaders were so infatuated with Hellenic glories that they were afraid to visit Greece lest it fail to live up to their expectations.

The linear art of the period is far more inventive and audacious than it might first appear. It is much more than an orthodox and rigidly accurate style based upon engravings after the recently-excavated art of Pompeii. Such artists as Jacob Asmus Carstens were enthusiastic followers of English draughtsmen like Flaxman and Blake. One of his watercolors, the *Embarcation of Megapenthes* of 1795, presents a stripped-down prophecy of Géricault's *Raft of the Medusa,* which was painted more than twenty years later.

The dividing line between drawings of the Neo-Classic linear style and those of the Romantic period is difficult to ascertain. Such artists as Fuseli could work in both manners with equal conviction. The Romanticism still dormant in Carsten's powerful art is more readily apparent in the turbulent vision of Fuseli. Born in Zurich in 1741, largely a self-taught artist who rose to the ranks of Keeper and Professor of the Royal Academy of England, Heinrich Fuseli was also a brilliant writer on art. He rejoiced in profoundly dramatic subjects, combining the aesthetic of the Picturesque with an even wilder and more expressionistic furor. His ghoulish, often frenzied drawings are based on Mannerist works of the sixteenth century. Interested in both Shake-

spearean subjects and Nordic mythology, he led the way to the increasingly nationalistic art of the early nineteenth century.

German-speaking artists and patrons turned from the exotic, the classical and the Italian in favor of subjects and style supposedly based on their Northern heritage. This Gothic Revival, like so many German movements, had already been intensively, albeit whimsically, explored by the English half a century before. Indeed, among the most potent influences on German art of the nineteenth century was that of England, so much of whose cultural history is enmeshed with that of the North. Just as German musicians and princelings were in constant English demand, the Germans adored the art of Hogarth, and later generations of German academicians idolized Flaxman's pristine draughtsmanship. The Romantic generation, despite its loving and often absurd recreation of a medieval heritage, retained much of the emphasis upon pure line of the immediately preceding Neo-Classicism. In rare instances, such as the work of Caspar David Friedrich and Philipp Otto Runge, the attempt to consciously recreate an indigenous art resulted in the sublime, rather than the ridiculous. A pious, secretive soul, Friedrich's drawings and paintings of Christian revelation in a Gothic landscape produce as moving and miraculous a fusion of art, faith and nature as that achieved by the Danubians of the early sixteenth century. His works unite their lyrical mysticism with the Arcadian nostalgia of his academic instructors. Only twentieth-century Paul Klee, among the many later German artists grappling with the same subjects, has been able to reach those rarefied heights where spirit and nature reveal themselves in each other.

Steeped in the Catholic Revival of the first third of the nineteenth century, German artists reached for the best of two worlds—striving to combine the Gothic with the Renaissance. Under the leadership of Franz Pforr and Overbeck, and with the patronage of the King of Bavaria, they set up a confraternity of Rome in 1810. Known as the Nazarenes, they strove to emulate the life

Figure 4
Gottfried SCHADOW · *Portrait of Queen Louise of Prussia*
pen and chalk, 320 x 249 mm.
Stuttgart, Staatliche Kunstsammlungen

as well as the art of their beloved, uncorrupted *Quattrocento*. While the slightly hysterical sentiment of their paintings, like those of their later English sympathizers—the Pre-Raphaelites—may disturb rather than inspire, the Nazarenes' drawings are easy to enjoy.

The art of the Nazarenes, with its extremely conservative goals and aristocratic support, dwindled toward the middle of the nineteenth century. With the headlong advance of the Industrial Revolution and bourgeois prosperity, German art moved toward the most meticulously daguerreotyped portraits of a Winterhalter and the polite realism of the Düsseldorf Academy. The only other permissible alternative was that of the wistful, fairy-tale art of Moritz von Schwind and his circle.

In the 1850's a more robust, full-blooded classicism came in, with Anselm Feuerbach as its leader. His stoical, brooding matrons, their sturdy forms more reminiscent of the Ruhr than Rome, presented an art of considerable authority and power. An artist of the next generation, Hans von Marées, while still concerned with a heroic, forceful art with a clear bloodline to the baroque and classical antiquity, created a much more vital art. Close to Rubens in spirit, fully aware of the art of Delacroix and Courbet as well, Marées' many very beautiful drawings and paintings present a world that is at once real and ideal. A master of the nude, Marées added vivacity and warmth to the chilly monumentality of mid-nineteenth-century German art. His ability to give a sense of the personal and the experienced to traditional formulas led the way for German draughtsmen away from the niggling realism and the quaint repertoire of polite genre toward the more intense art of von Stück, Lenbach and Makart.

Still later, other more adventurous artists, receptive to currents in France, became interested in the forerunners of Impressionism. Menzel, one of the most gifted draughtsmen of the century, made many astonishingly direct, vivid drawings and preparatory studies for his highly-finished paintings. His

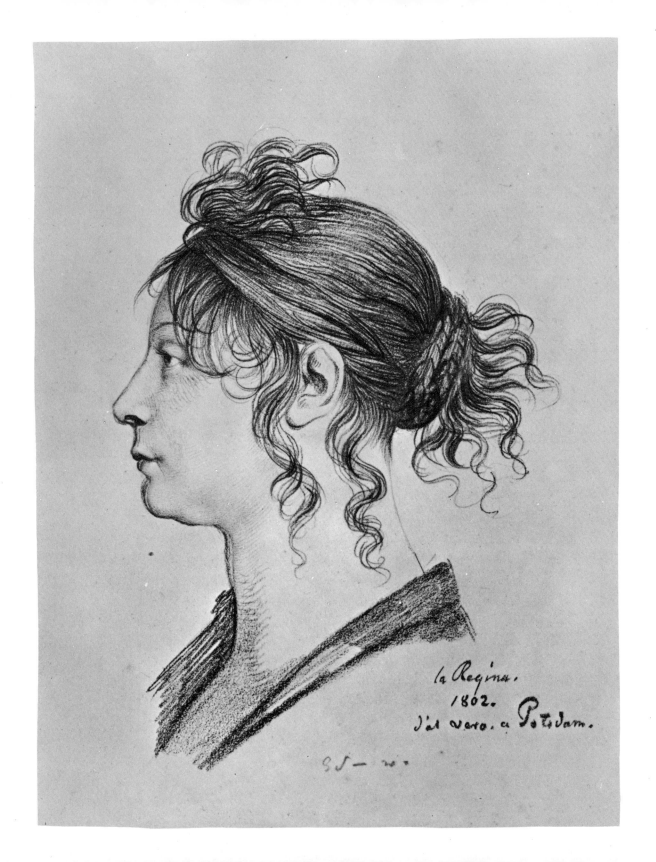

la Regina.
1802.
J'ai vero. a Potsdam.

31

many historical paintings celebrating the French-influenced court of Frederick the Great, may well have made Menzel receptive to the new currents from the France of his own day.

Even more than Trübner and Leibl, the other masters of realistic rendering in the later nineteenth century, Menzel's drawings fill the spectator with a sense of wonder for what Goethe called "the seeing hand and the feeling eye," rather than for sheer technical virtuosity.

Lieberman and Slevogt, admirers of Manet, translated the spontaneity and elegance of his art into a sturdy German facsimile. It is among the most popular German academic artists at the close of this century—such as Arnold Böcklin and von Stück—that drawings afford the greatest surprises. Böcklin's beautiful *Head of a Triton* proves that his great popularity depended upon pulsating talent as well as his knack for capturing the popular imagination.

Reacting against the sentimentality and excessive detail of so much art toward the end of the century, a new movement stressed a more direct grasp of line and form. Artists like Klimt and Hodler embraced a more abstract art, replacing the anecdotal with the analytical. Inspired by William Morris in England and Puvis de Chavannes in France, the German and Austrian artists of the period, in close contact with Belgian and Scandinavian developments, evolved a new art form—the *Jugendstil* or youth style, known in France as *Art Nouveau*. Returning to the purism of the Neo-Classical, this new style abounds in sinuous tendril-like lines, bringing German art full circle. It reasserts the native trend toward line that is at once organic and abstract.

COLIN T. EISLER

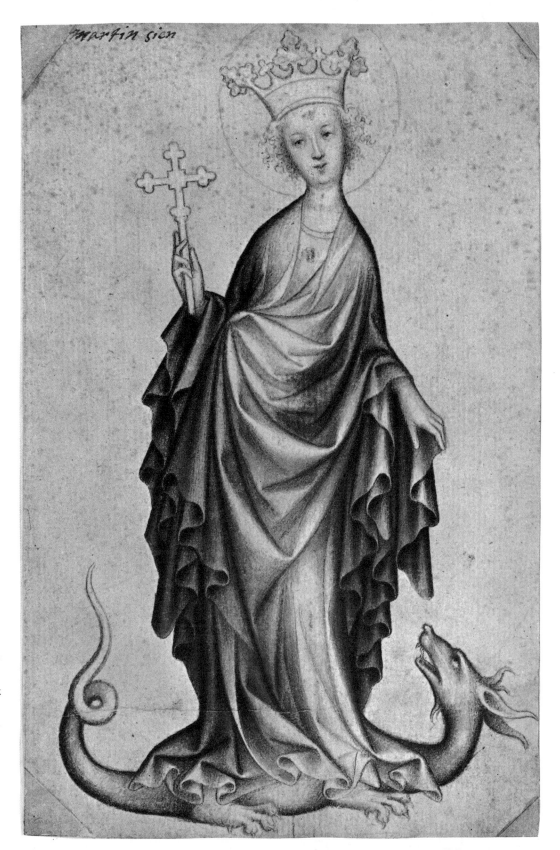

Plate 1
AUSTRIAN Master, ca. 1400
Saint Margaret and the Dragon
red chalk, brush and India ink
214 x 140 mm.
Budapest, Museum of Fine Arts

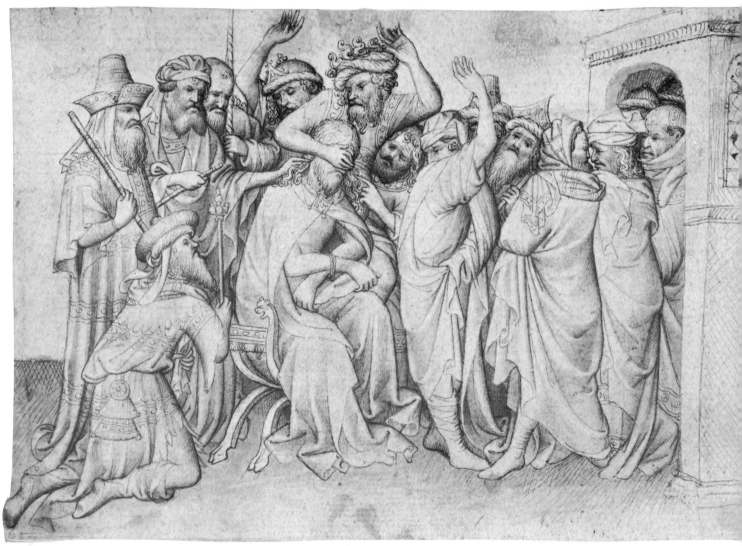

Plate 2

AUSTRIAN Master, ca. 1415 · *The Mocking of Christ* · pen and brush in India ink, 139 x 208 mm.
Copenhagen, Royal Museum of Fine Arts

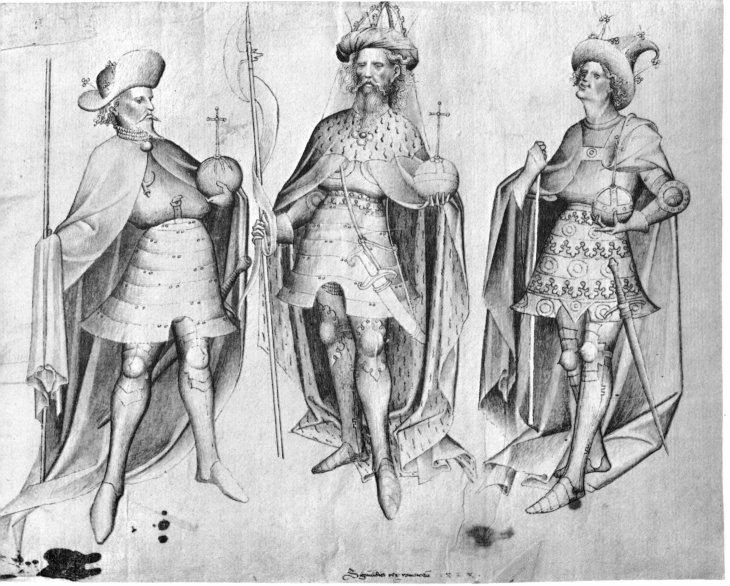

Plate 3

AUSTRIAN Master of 1424 · *Emperor Sigismund with the Kings of Bohemia and Hungary* · pen and wash on white paper,
203 x 265 mm. · Paris, Louvre, Collection Rothschild

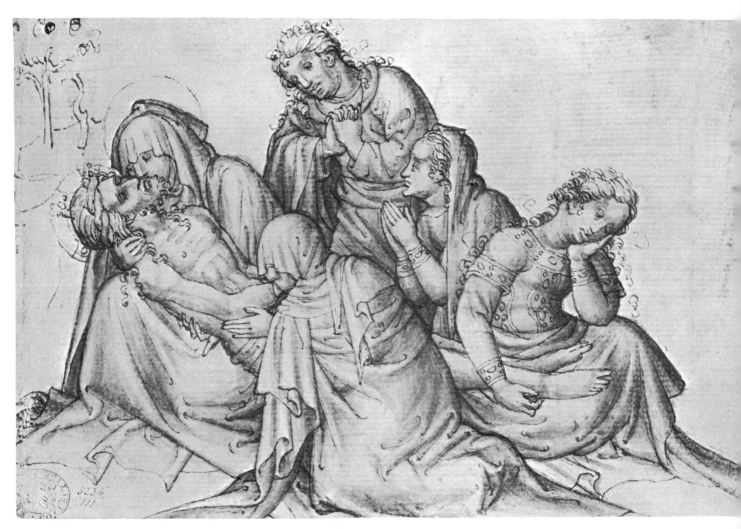

Plate 4
The Master of the VOTIVE Panel of Saint Lambrecht, ca. 1430 · *The Lamentation for Christ* (recto) · pen and wash in India ink, 140 x 208 mm. · London, The British Museum

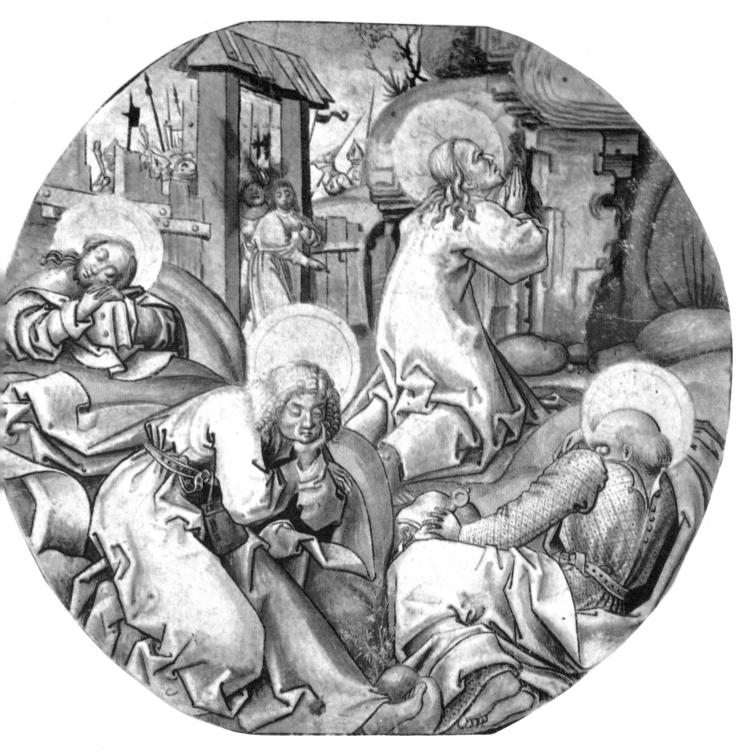

Plate 5

GERMAN, 15th Century • *The Agony in the Garden* • pen and ink, sepia wash and color tints, 190 to 203 mm. Diameter
Frankfort-on-Main, Staedel Art Institute

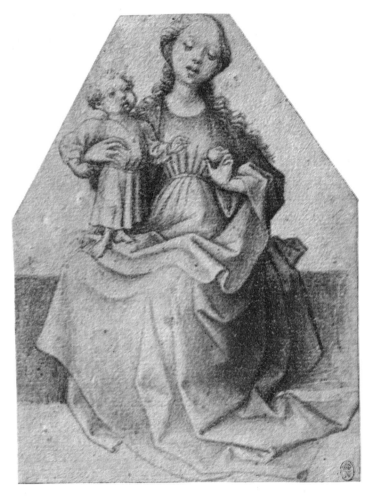

Plate 6
Stephan LOCHNER · *The Virgin Seated, Presenting an Apple
to the Child* · pen and wash in India ink, 125 x 95 mm. · Paris, Louvre

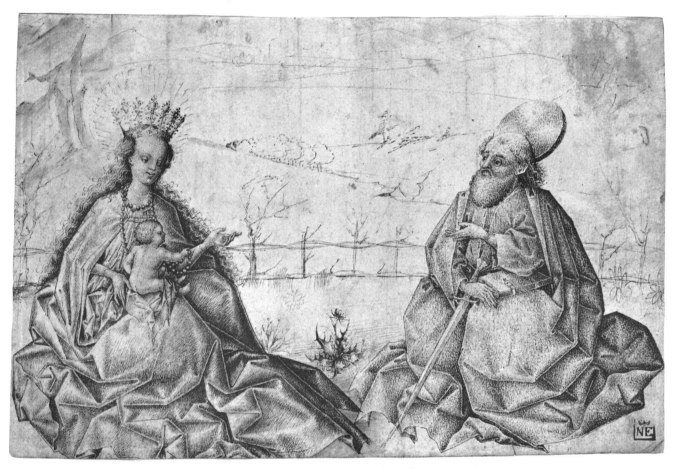

Plate 7

Master of the Circle of Konrad WITZ · *The Virgin and Child with St. Paul, Seated in a Landscape* · pen and India ink, 180 x 272 mm. · Budapest, Museum of Fine Arts

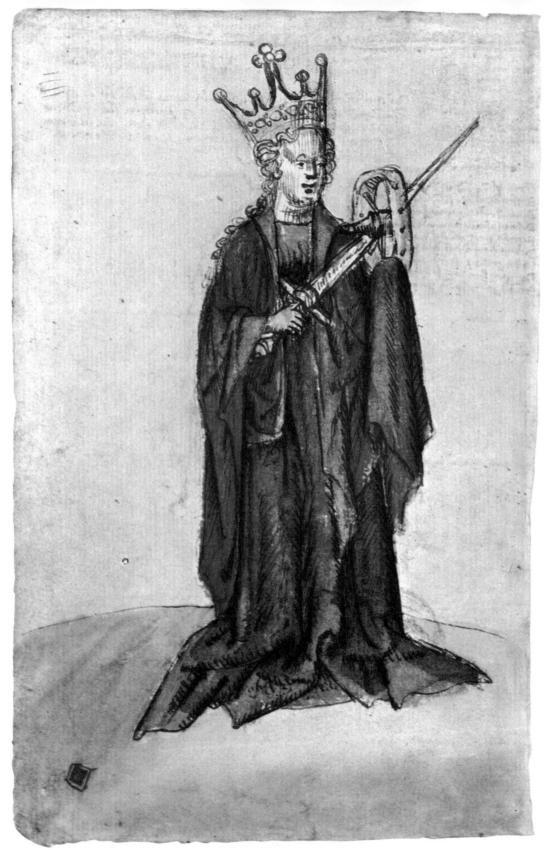

Plate 8
VIENNESE Master of 1441-144?
Saint Catherine
pen and bistre, water color ove
preparatory traces in black cha
219 x 140 mm.
Vienna, Albertina Gallery

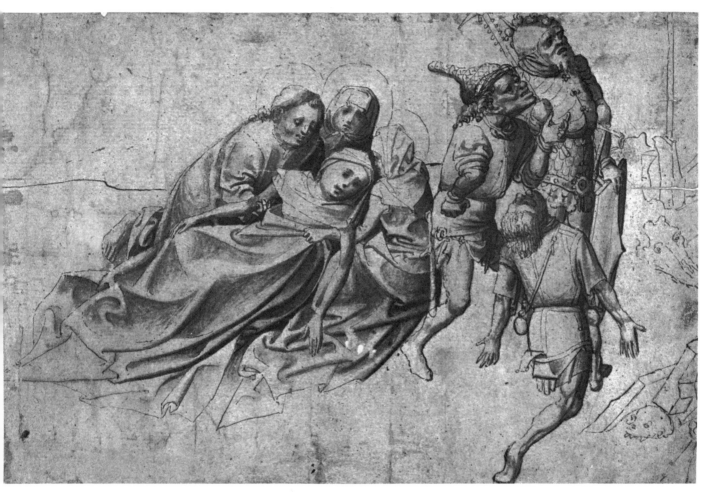

Plate 9

Master of the WORCESTER Carrying of the Cross, ca. 1440-1450 · *Group at Calvary* · pen and wash in India ink, 153 x 231 mm. · Frankfort-on-Main, Staedel Art Institute

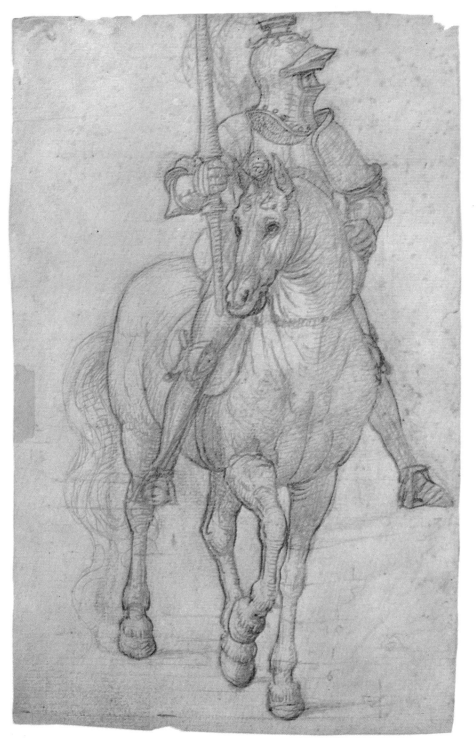

Plate 10
GERMAN
Knight on Horseback
pen and bistre with ochre brush
work on tan paper, 188 x 122 mm.
Milan, Biblioteca Ambrosiana

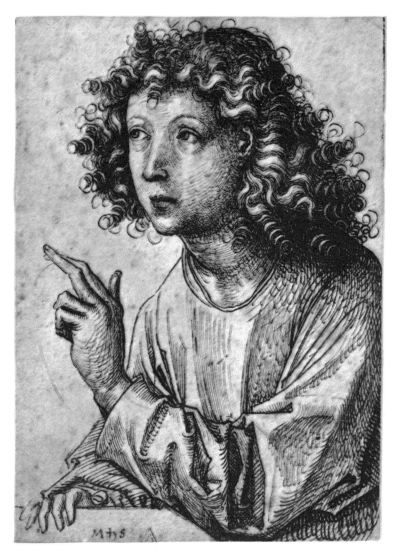

Plate 11
Martin SCHONGAUER
*The Angel Gabriel for an
Annunciation* (half-length)
pen and India ink, 140 x 99 mm.
Berlin, Kupferstichkabinett

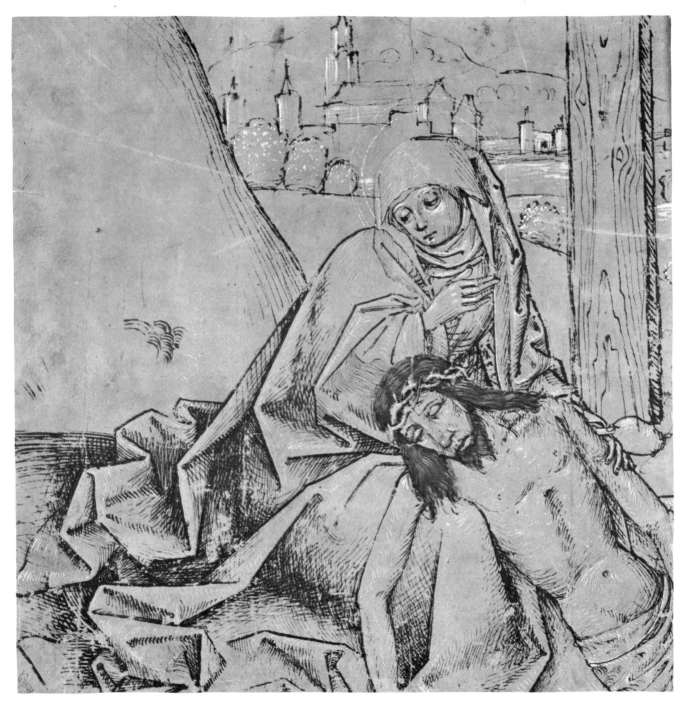

Plate 12
South GERMAN (Swabian?), ca. 1470 • *Mary with the Body of Christ at the Foot of the Cross* • pen and India ink,
heightened with pinkish-white and gold, on bluish-green-prepared paper, 180 x 180 mm. • Vienna, Albertina Gallery

Plate 13

Viet STOSS • *The Presentation in the Temple* • pen and bistre, 114 x 178 mm. • Berlin, Kupferstichkabinett

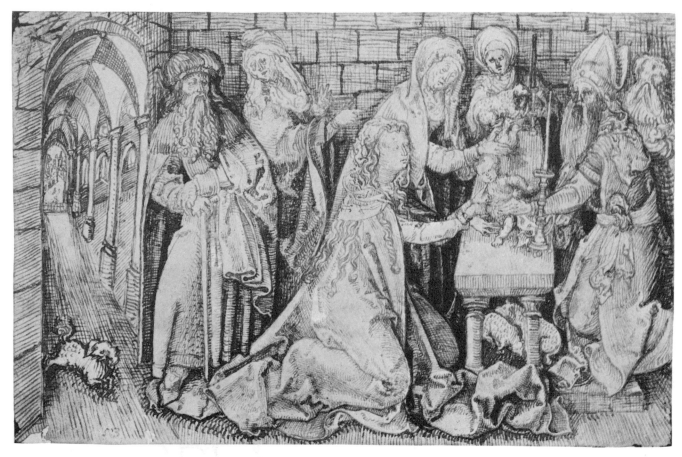

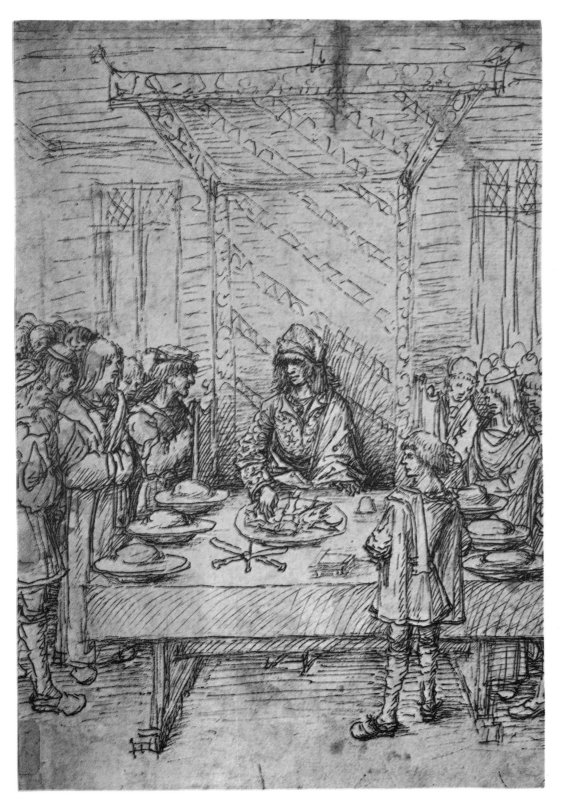

Plate 14
The Master of the
HOUSEBOOK, ca. 1475-1500
*Maximilian I at the Peace
Banquet at Bruges in 1488*
pen and bistre, 277 x 192 mm.
Berlin, Kupferstichkabinett

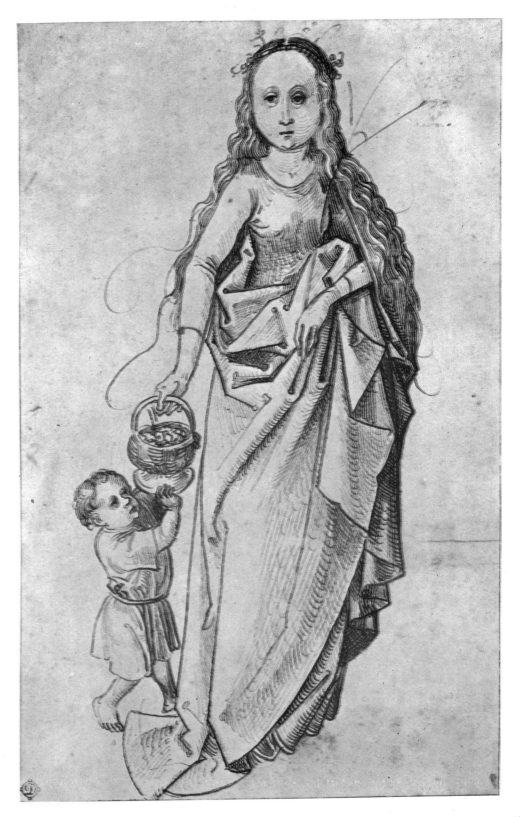

Plate 15
Follower of Martin
SCHONGAUER, ca. 1490
*Saint Dorothy Holding Out a
Basket to the Christ Child*
pen, bistre and India ink
206 x 133 mm.
London, The British Museum

48

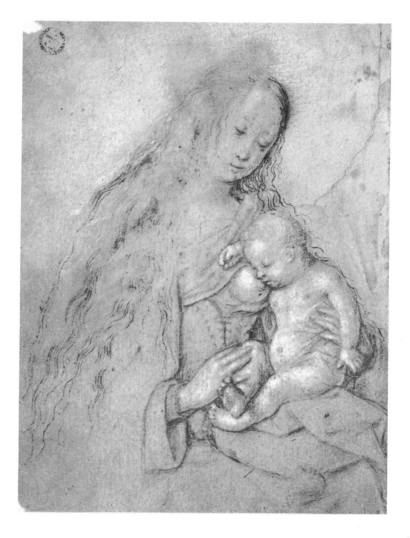

Plate 17
Hans HOLBEIN the Elder
*The Virgin Offering Her Breast
to the Sleeping Child*
silverpoint on gray-prepared paper
heightenings in white, reinforced
with pen, 140 x 106 mm.
Basel, Kupferstichkabinett

Plate 16

Bernhard STRIGEL · *A Pair of Lovers with the Devil and Cupid* · pen and India ink and white and reddish body-color
on slate-gray-prepared paper, 225 x 176 mm. · Berlin, Kupferstichkabinett

49

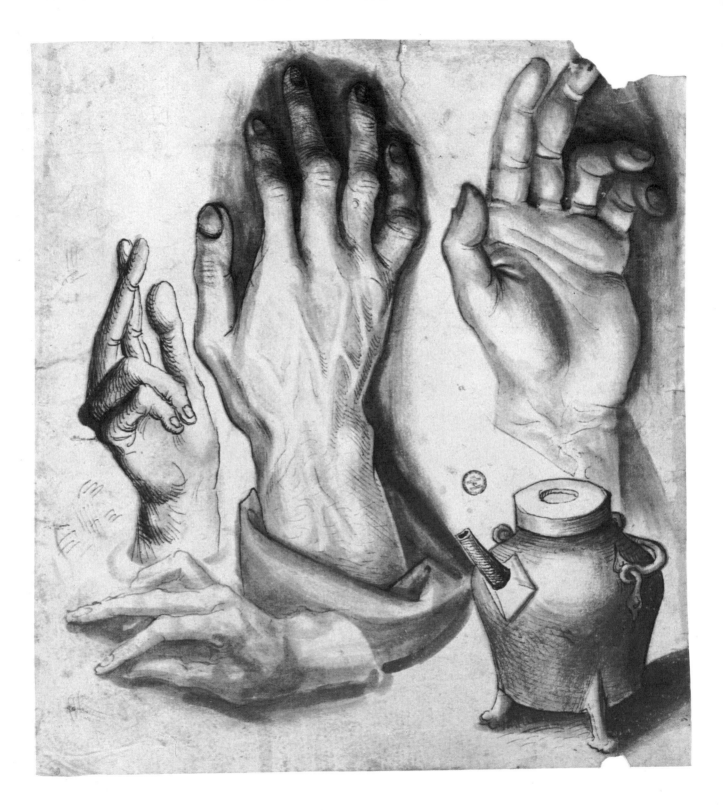

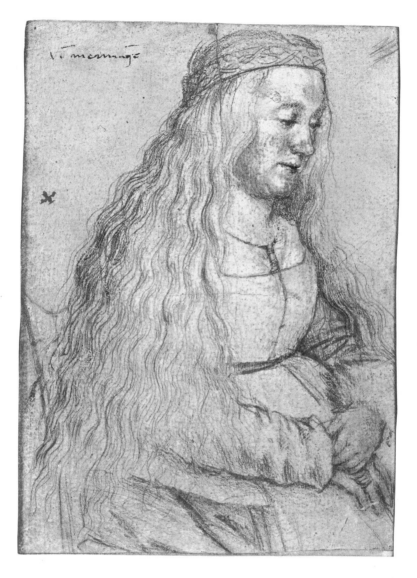

Plate 19
Hans HOLBEIN the Elder
Seated Woman with Long Loose Hair
silverpoint on prepared paper
with some heightenings in red and
white chalks, reinforced in pen
140 x 103 mm.
Copenhagen, Royal Museum
of Fine Arts

late 18

Hans HOLBEIN the Elder • *Studies of a Hand and a Tea Kettle* • black and sepia ink and wash with a touch of reddish wash,
222 x 205 mm. • Basel, Kupferstichkabinett

51

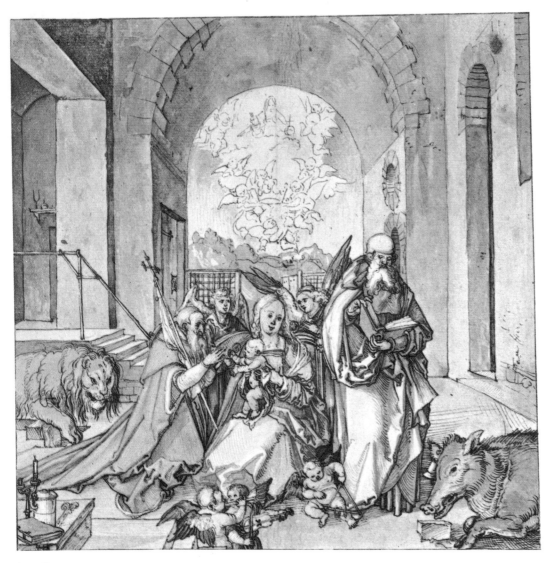

Plate 20

Hans Suess von KULMBACH · *The Holy Virgin and Child with Angels Making Music,*
Saint Jerome and Saint Anthony (detail) · pen and ink, bistre, 203 x 405 mm.
Vienna, Albertina Gallery

Plate 21

Hans HOLBEIN the Elder · *An Old Woman Sleeping* · silverpoint, 93 x 129 mm. · Bayonne, Musée Bonn

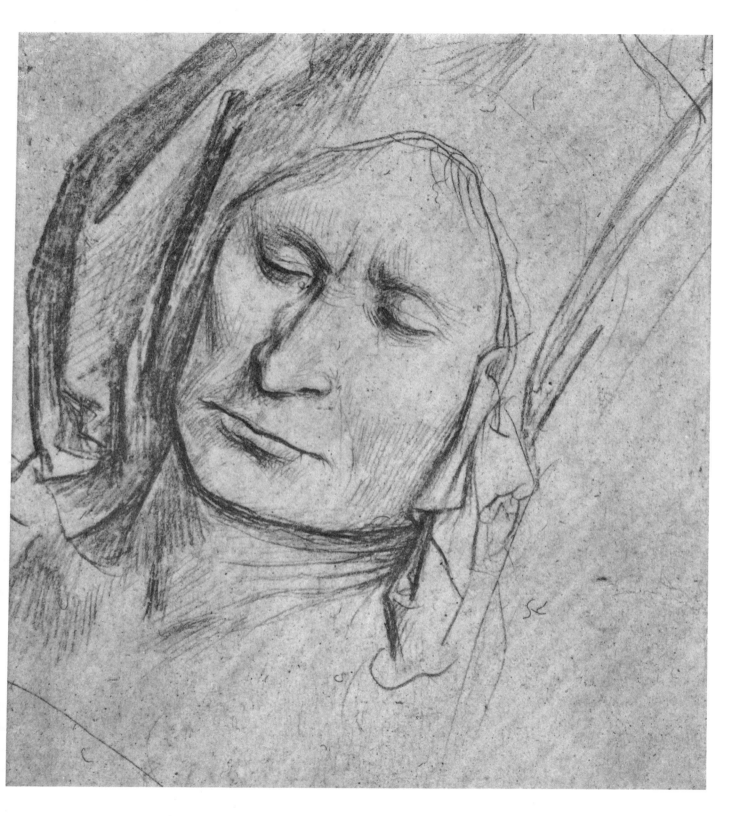

53

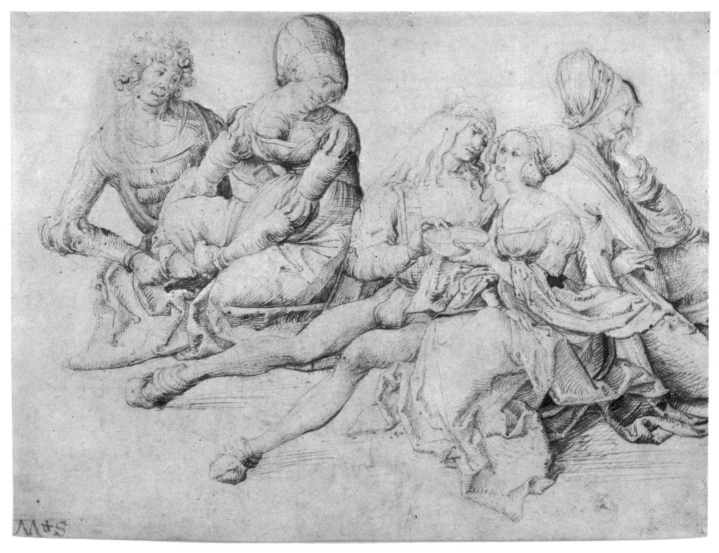

Plate 22
Hans Suess von KULMBACH · *Two Pairs of Lovers and an Old Woman* · pen and bistre over pencil traces, 184 x 253 mm.
Munich, Staatliche Graphische Sammlung

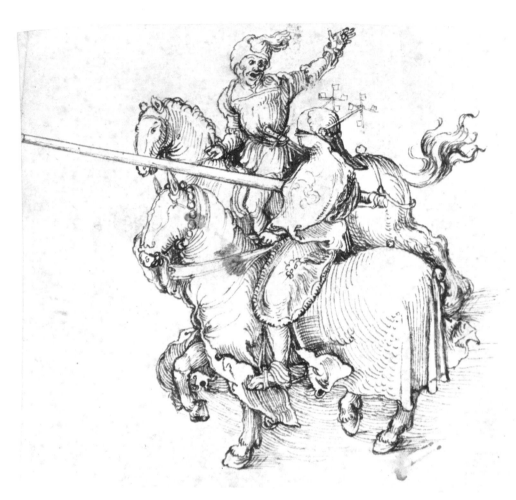

Plate 23

Hans Suess von KULMBACH · *Two Men on Horseback* · pen and brown ink, 140 x 132 mm.
London, The British Museum

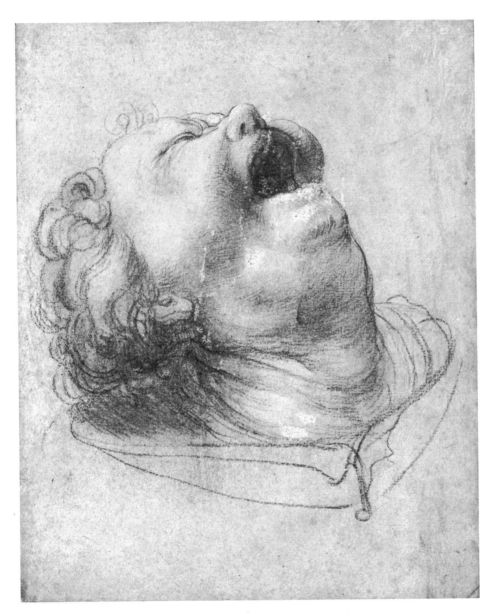

Plate 24

Matthias GRUNEWALD · *Head of a Weeping Angel* · black chalk,
heightened with white, 244 x 199 mm. · Berlin, Kupferstichkabinett

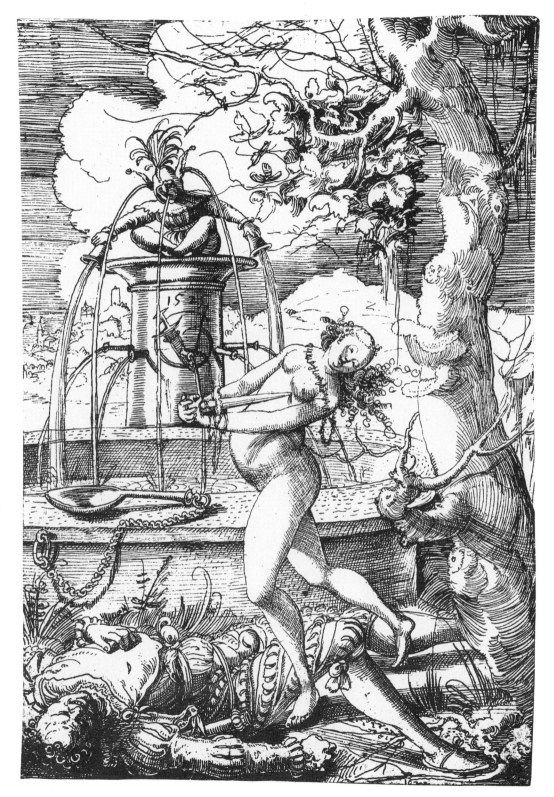

Plate 25
Urs GRAF
Pyramus and Thisbe
pen and black ink
on yellowish paper
290 (295?) x 200 (205?) mm.
uneven
Basel, Kupferstichkabinett

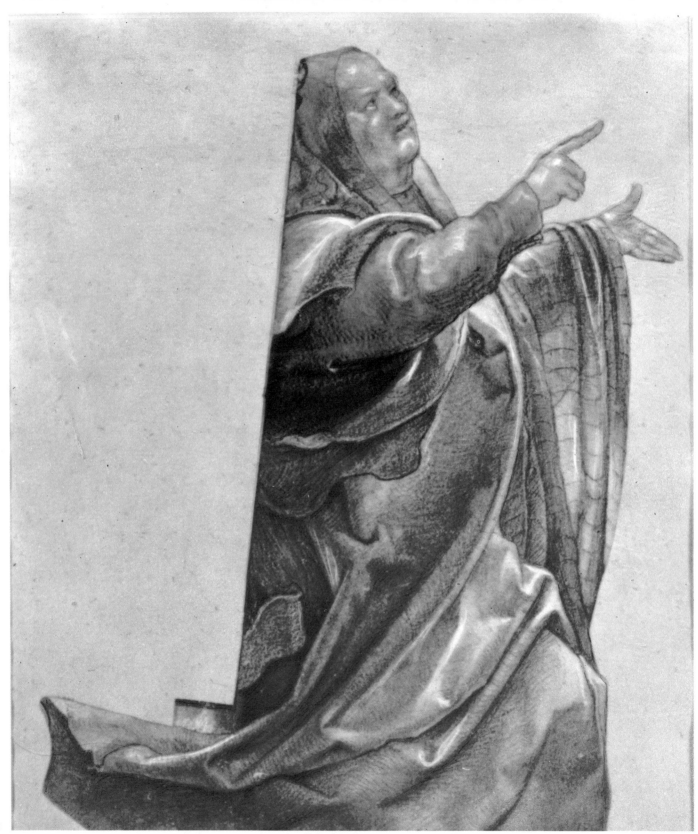

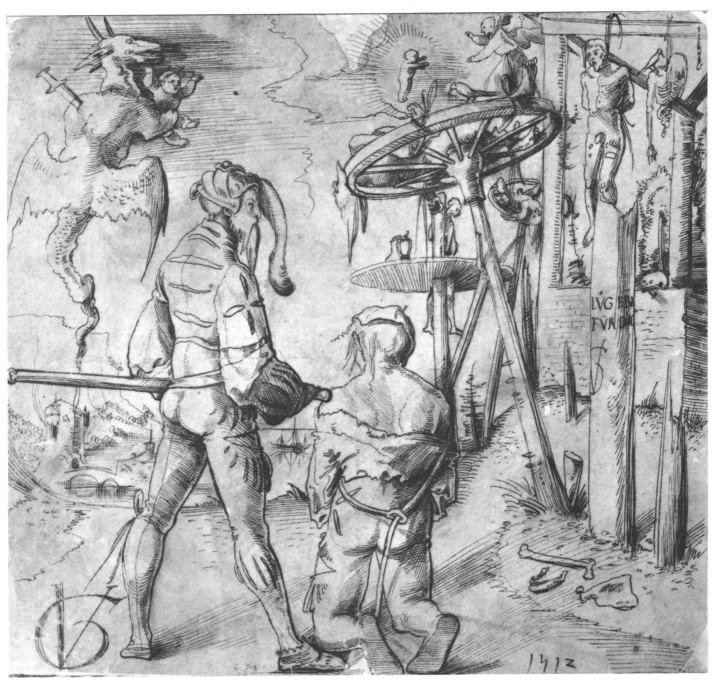

Plate 27
Urs GRAF • *Place of Execution* • pen and India ink, 218 x 238 mm. • Vienna, Albertina Gallery

Plate 26
Matthias GRUNEWALD • *Kneeling Man with Raised Hands* (detail) • black chalk, heightened in white body-color,
gray wash on yellowish paper, 234 x 165 mm. • Berlin Kupferstichkabinett

59

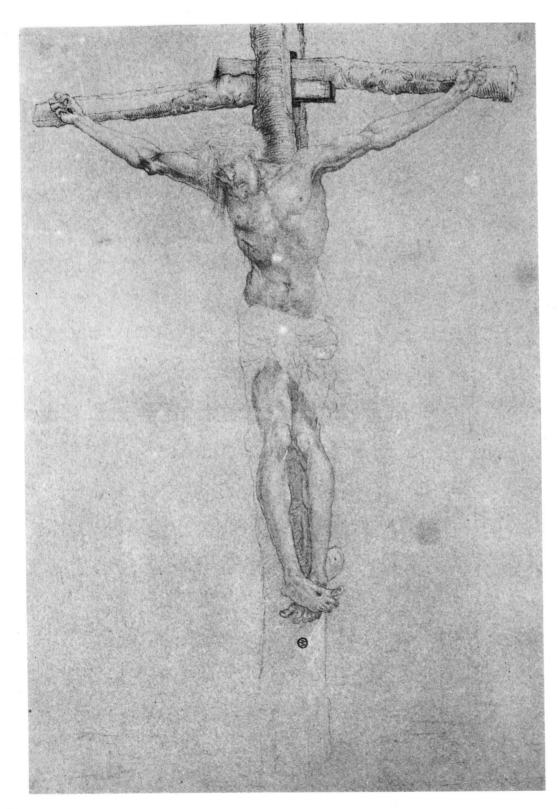

Plate 28
Matthias GRUNEWALD
Crucifixion
black chalk on blue paper
550 x 385 mm.
Basel, Kupferstichkabinett

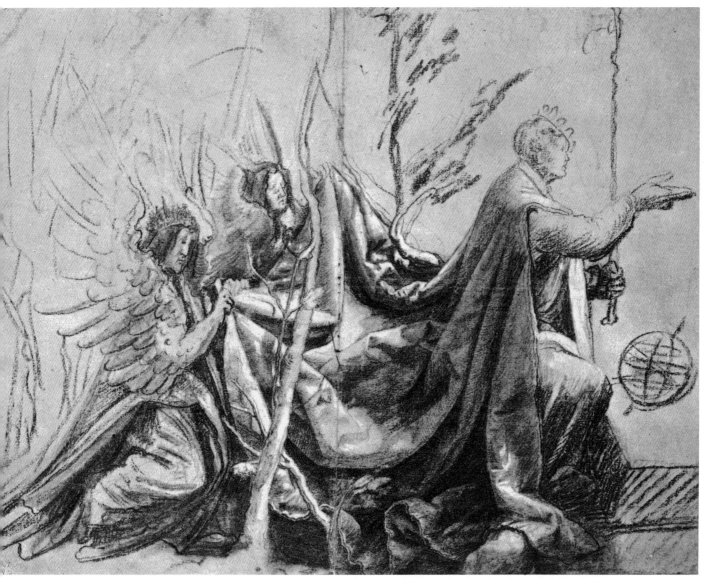

Plate 29

Matthias GRUNEWALD · *Christ the King, Whose Train is Carried by Two Angels (Recto)* · black chalk, heightened in white body-color, gray wash, on brownish paper, 286 x 366 mm. · Berlin, Kupferstichkabinett

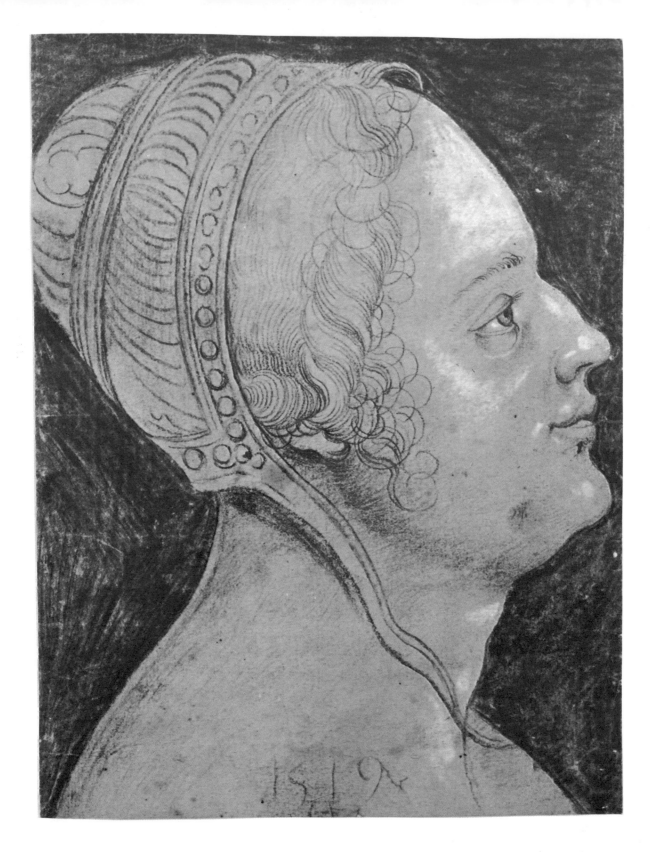

Plate 30
Hans BALDUNG GRIEN
Portrait of a Young Woman in Profile to Right
black chalk, heightened with the brush in white, 207 x 159 mm.
Berlin, Kupferstichkabinett

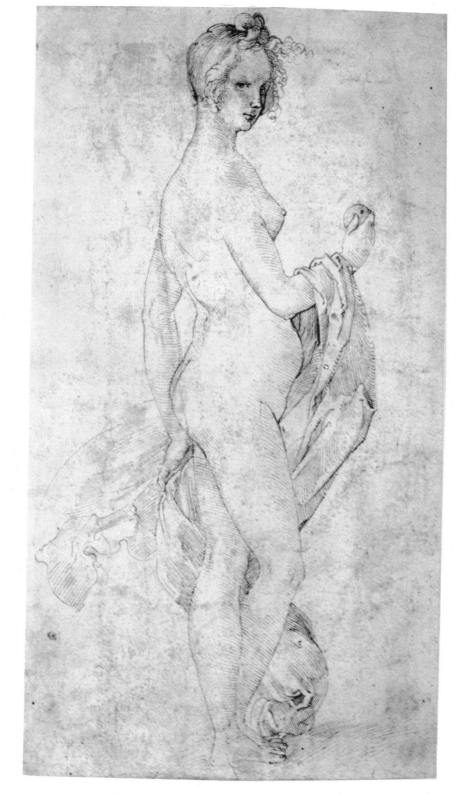

Plate 31
Hans BALDUNG GRIEN
Venus with the Apple of Paris (?)
pen and brown ink on yellowish paper, 298 x 166 mm.
Berlin, Kupferstichkabinett

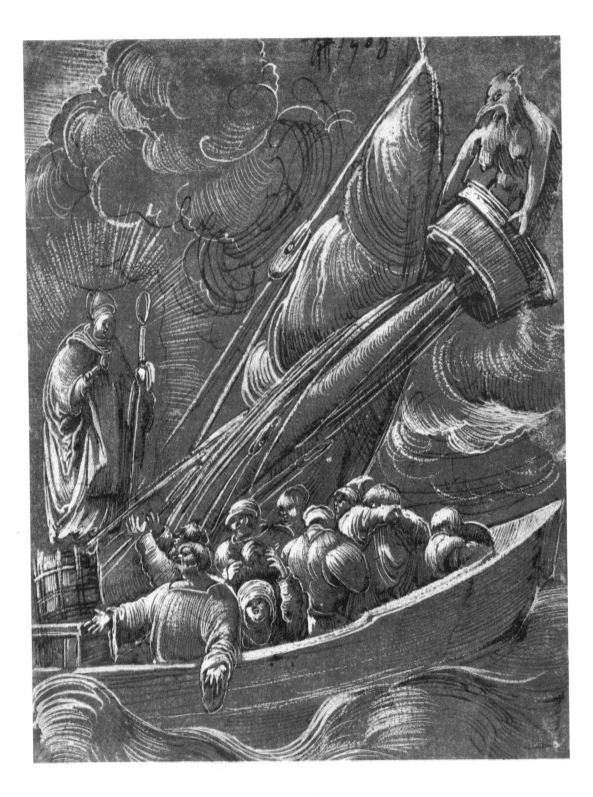

64

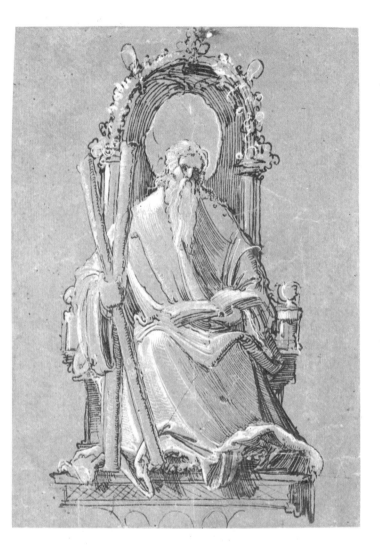

Plate 33
Albrecht ALTDORFER
Saint Andrew Enthroned
pen and India ink and white
body-color on green-prepared
paper, 161 x 116 mm.
Berlin, Kupferstichkabinett

ate 32
Albrecht ALTDORFER · *Saint Nicholas of Bari Rebuking the Tempest* · pen and India ink, heightened with the brush
n body-color on brick-red paper, 192 x 147 mm. · Oxford, Ashmolean Museum

65

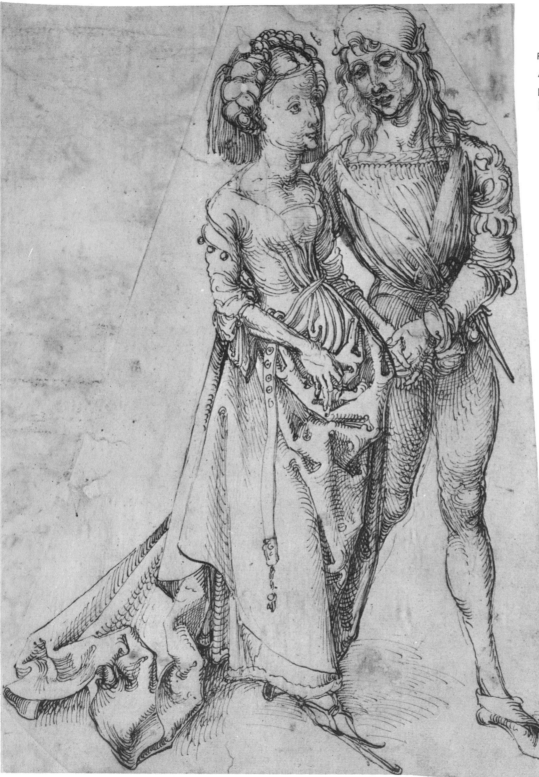

Plate 34
Albrecht DÜRER · *Young Couple*
pen and bistre · 258 x 191 mm.
Hamburg, Kunsthalle

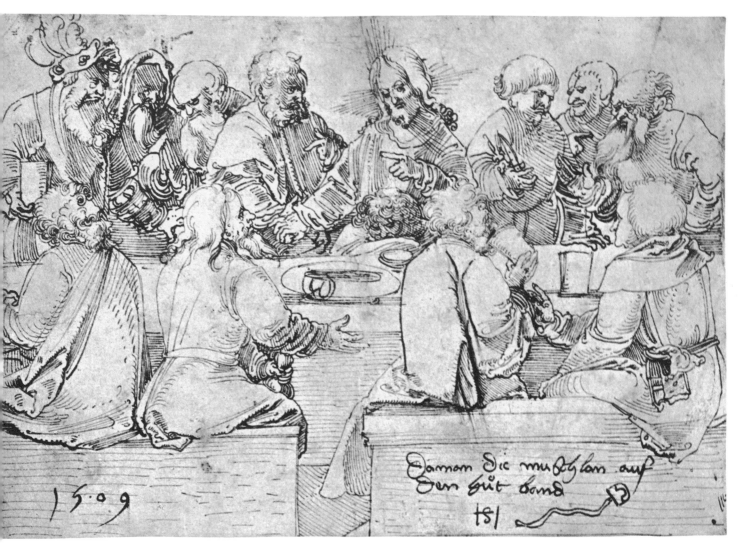

Plate 35
Hans Leonhard SCHAEUFELEIN · *The Last Supper* · pen and ink, 154 x 220 mm. · London, The British Museum

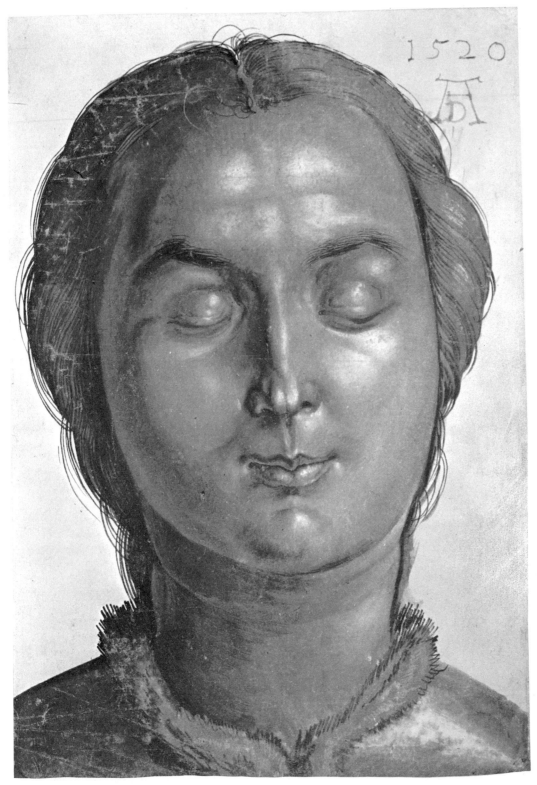

1520

Plate 36
Albrecht DURER
*Head of a Young Woman
with Her Eyes Closed*
brush and India ink, white
body-color, 326 x 226 mm.
London, The British Museum

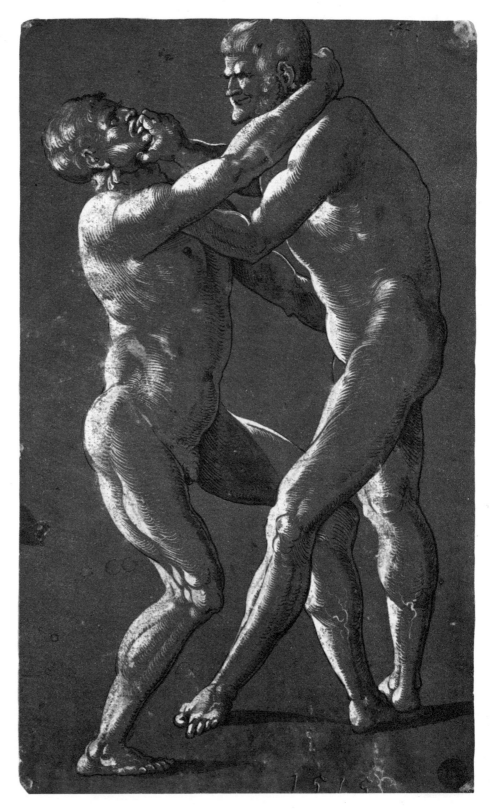

Plate 37
Hans BALDUNG GRIEN
Two Nude Men Fighting
pen and India ink and white body-
color on reddish-brown prepared
paper, 285 x 175 mm.
Venice, Accademia

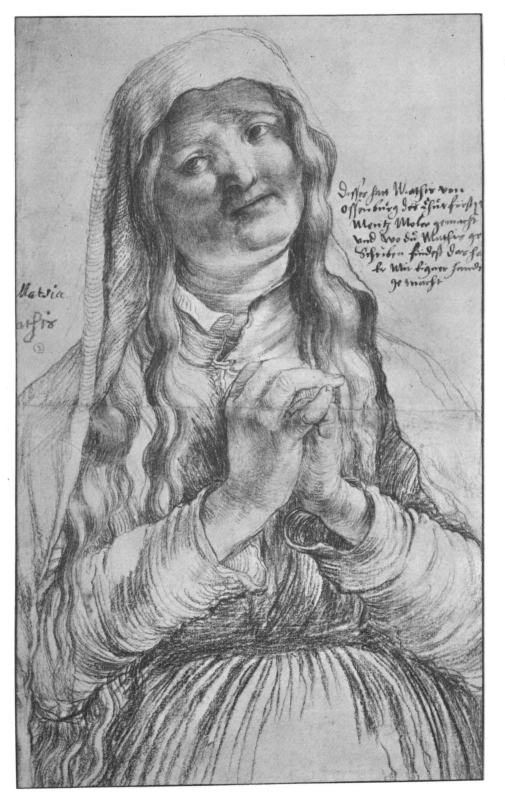

Plate 38
Matthias GRUNEWALD
An Elderly Woman
with Clasped Hands
charcoal, 377 x 236 mm.
Oxford, Ashmolean Museum

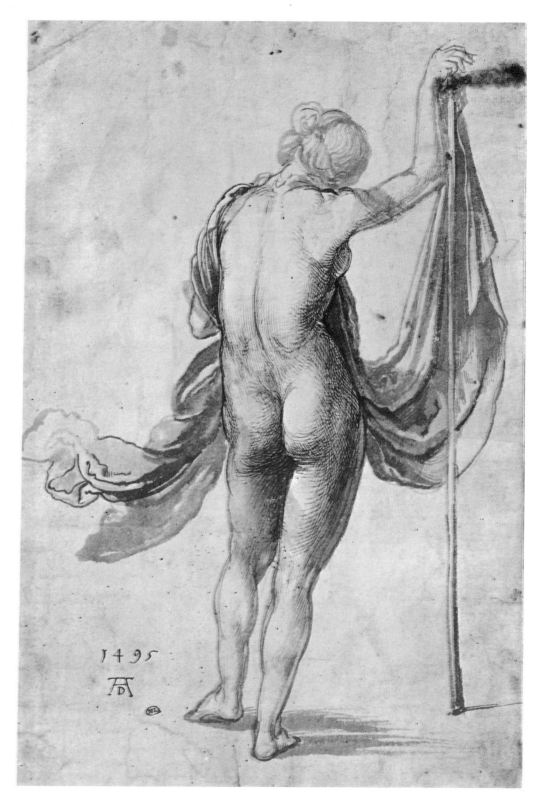

Plate 39
Albrecht DÜRER
*Female Nude Seen from
the Back, Holding a Staff
and a Drapery*
brush and India ink
320 x 210 mm.
Paris, Louvre

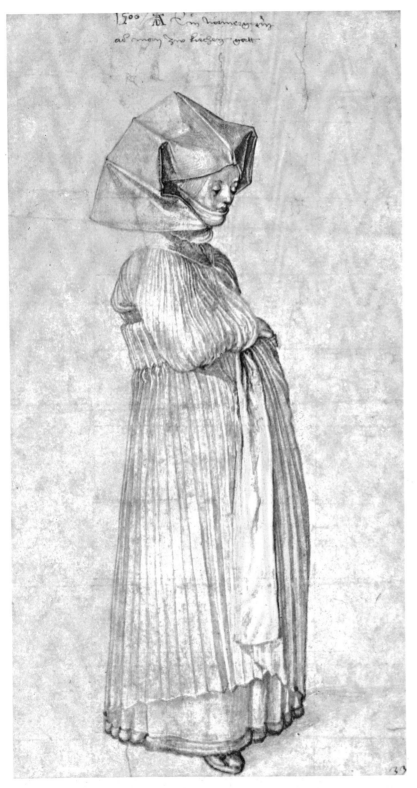

Plate 40
Albrecht DURER
*A Lady of Nuremberg
in Church Dress*
water color, 317 x 172 mm.
London, The British Museum

Plate 41
Hans SPRINGINKLEE
*The Rest of the Holy Family
on the Flight into Egypt*
pen and India ink and white
body-color on brown-prepared
paper, 224 x 162 mm.
London, The British Museum

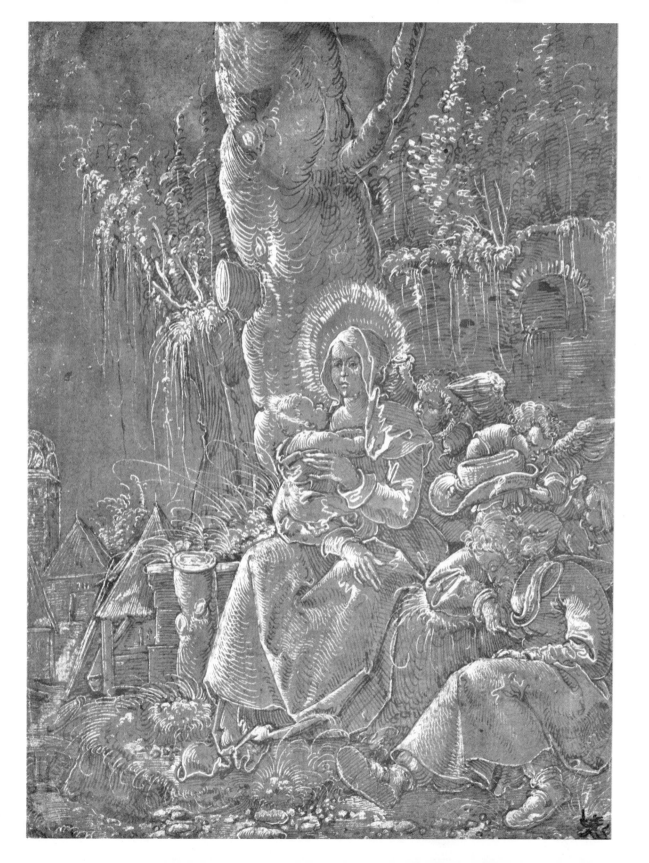

73

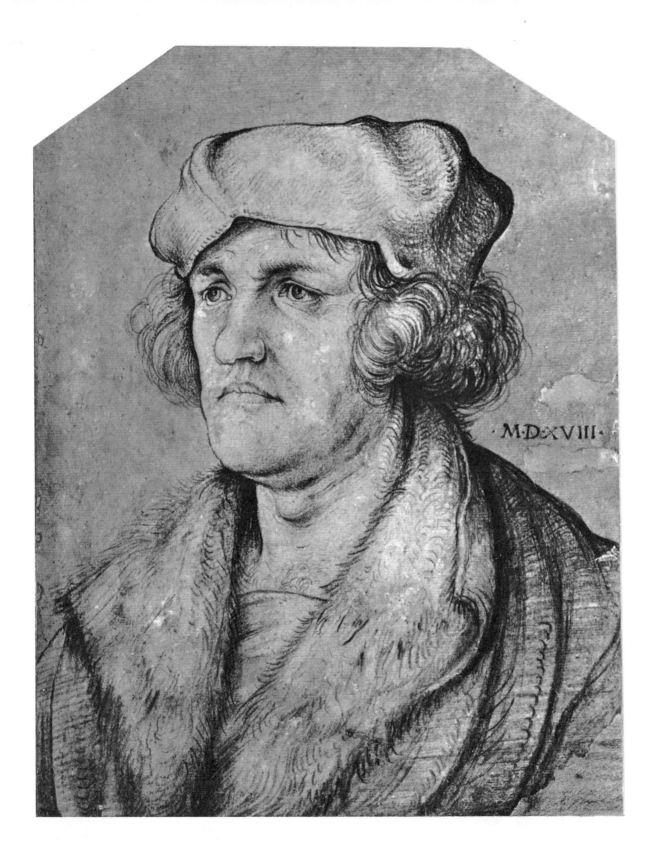

The text on the drawing reads: ·M·D·XVIII·

74

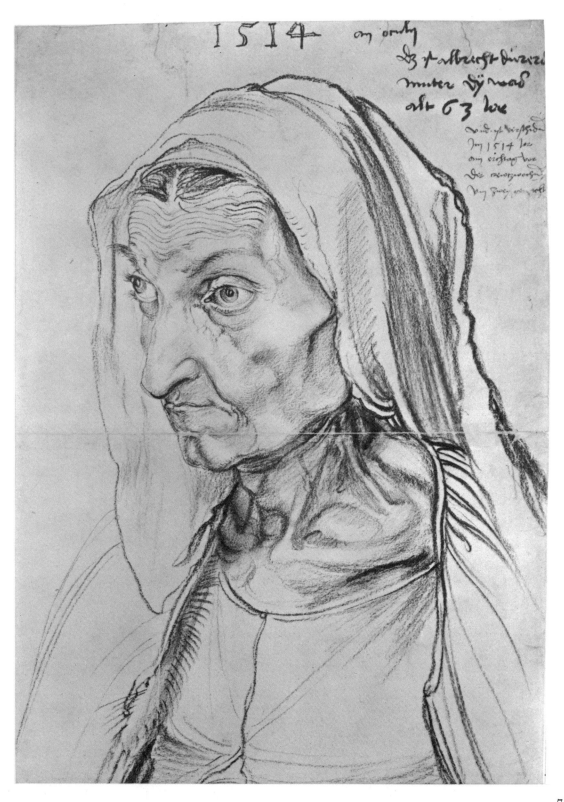

Plate 43
Albrecht DURER
Portrait of the Artist's Mother
charcoal, 421 x 303 mm.
Berlin, Kupferstichkabinett

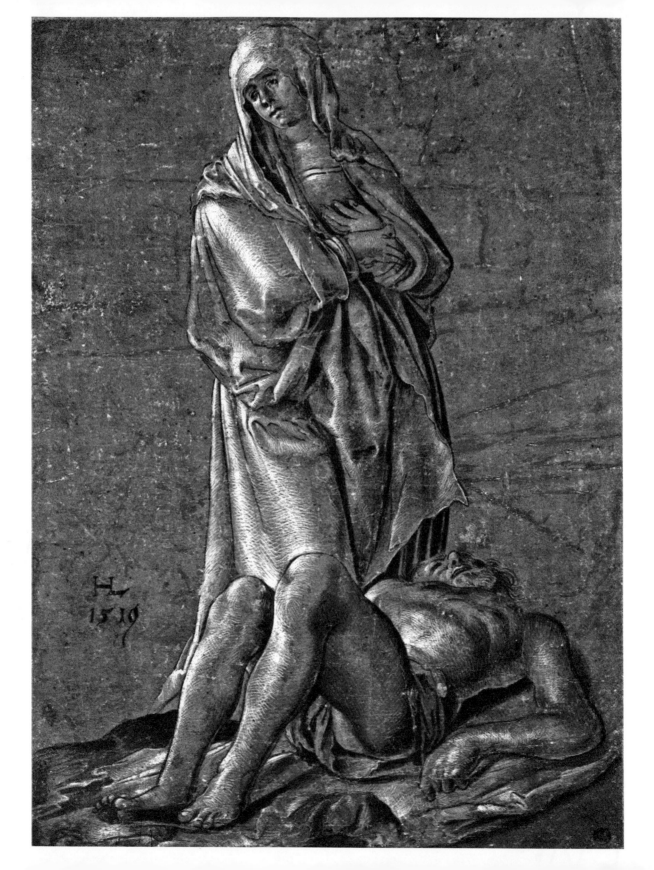

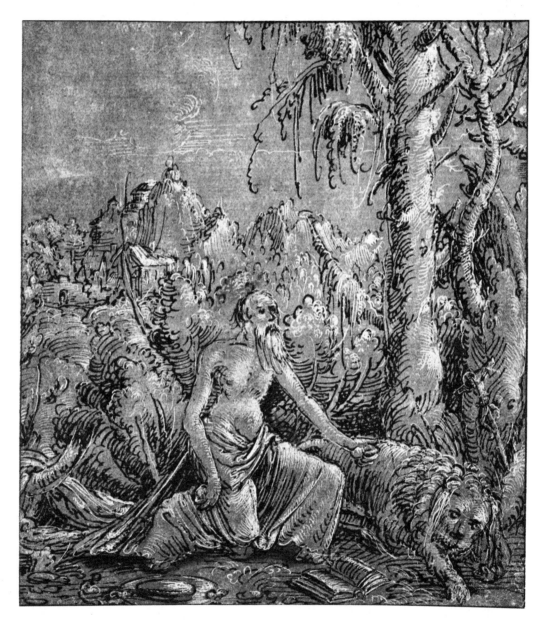

Plate 45
Hans LEU the Younger
Saint Jerome Repentant in a
Mountain Landscape
pen and India ink and white
body-color on grayish-purple
repared paper, 155 x 137 mm.
Frankfort-on-Main
Staedel Art Institute

Plate 44

Hans LEU the Younger · *Pietà* · pen and brush in carbon ink and gouache on green-prepared paper, 275 x 207 mm.
Cambridge, Mass., Harvard University, Fogg Art Museum, Gift of the Honorable Mr. & Mrs. Robert Woods Bliss

77

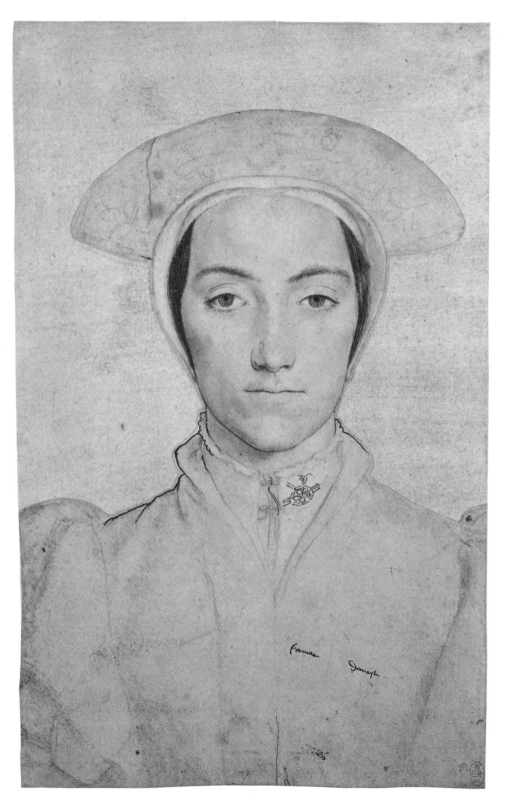

Plate 46
Hans HOLBEIN the Younger
A Lady (Unknown)
black, red and brown chalks
reinforced with pen in India ink
heightened with the brush in
white body-color, on pink primin
271 x 169 mm.
Windsor Castle
The Royal Collection

Plate
Albrecht DUR
Portrait of the Emper
Maximilia
charcoal, reddish flesh-col
with white heightening adde
381 x 319 m
Vienna, Albertina Galle

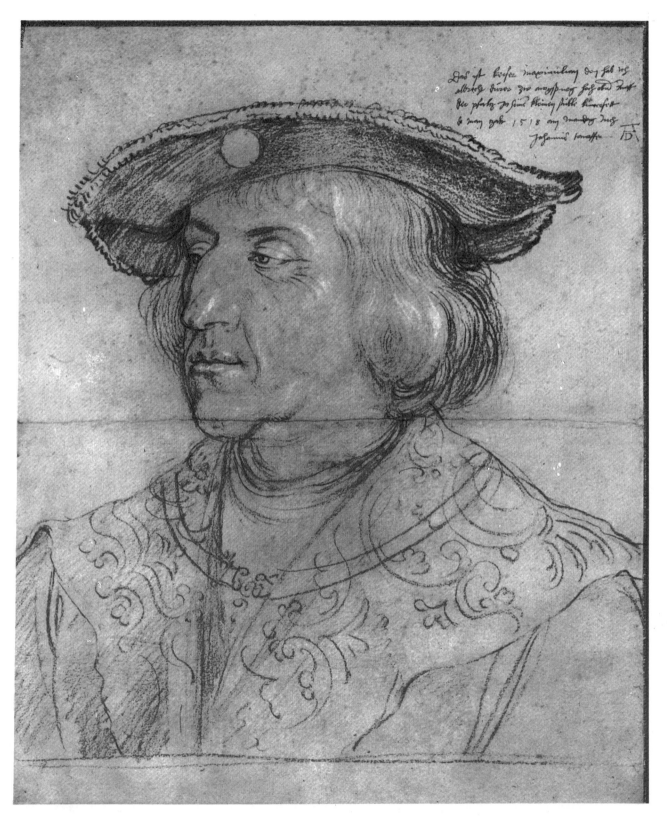

Das ist kaiser maximilian der sel er
altdorf dises zu angspurg hoch obend auf
der pfaltz zu seinn künig stübe kunterfet
do man zalt 1518 am mandag nach
Johannis tauffer — DÜ

79

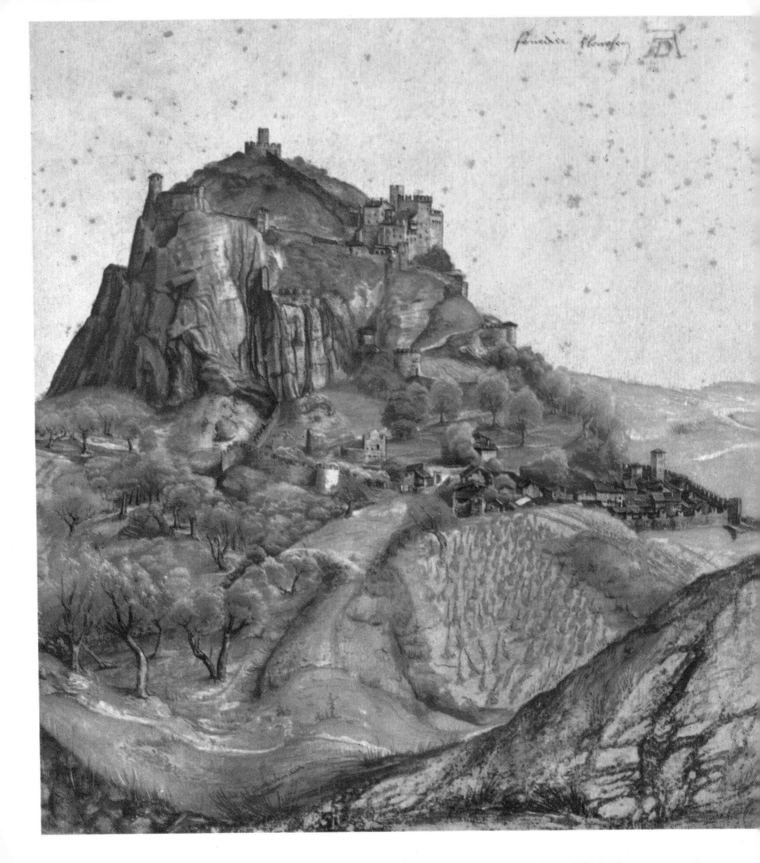

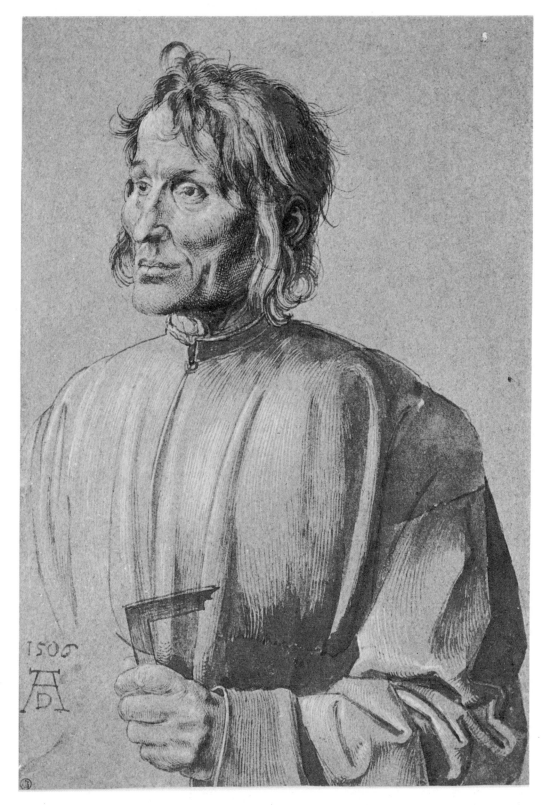

Plate 49
Albrecht DURER
Portrait of an Architect
brush and India ink and white
body-color on blue Venetian
paper, 386 x 263 mm.
Berlin, Kupferstichkabinett

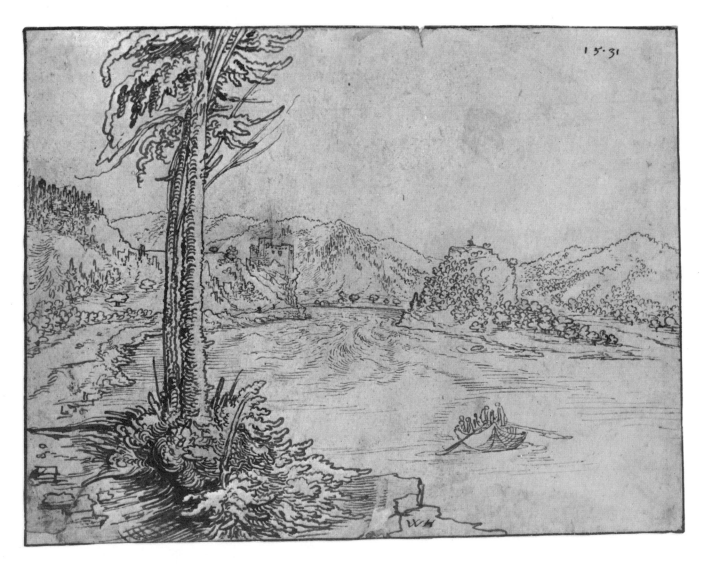

Plate 50
Wolf HUBER · *The Rapids of the Danube near Grien* · pen and ink, 159 x 212 mm. · Washington, D.C., National Gallery of Art

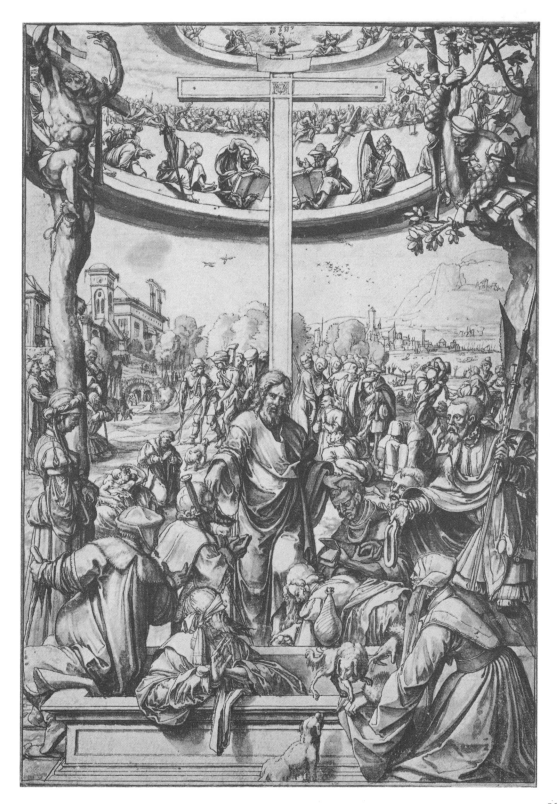

Plate 51
Herman tom RING
The Last Judgment
en in black and brown ink with
y-brown paper, 263 x 183 mm.
Vienna, Albertina Gallery

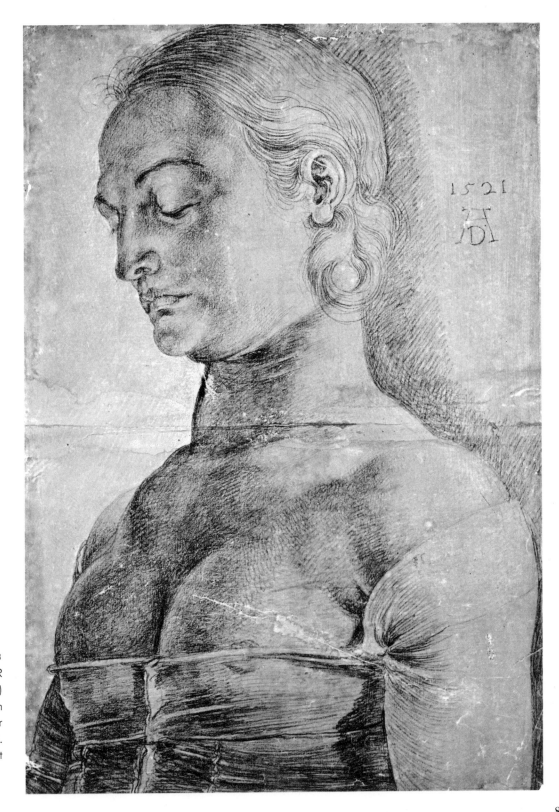

Plate 53
Albrecht DURER
Study for Saint Appollonia (Bust)
black chalk on
green-prepared paper
414 x 288 mm.
Berlin, Kupferstichkabinett

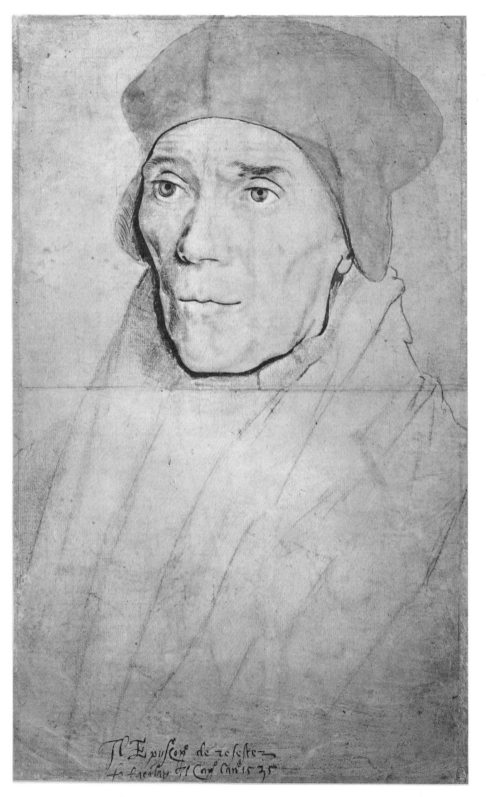

Plate 54
Hans HOLBEIN the Younger
Cardinal John Fisher
Bishop of Rochester
black and red chalk, washed in
brownish water color, reinforced
with brush and pen in India ink by a
later hand, on primed paper
383 x 234 mm.
Windsor Castle, The Royal Collection

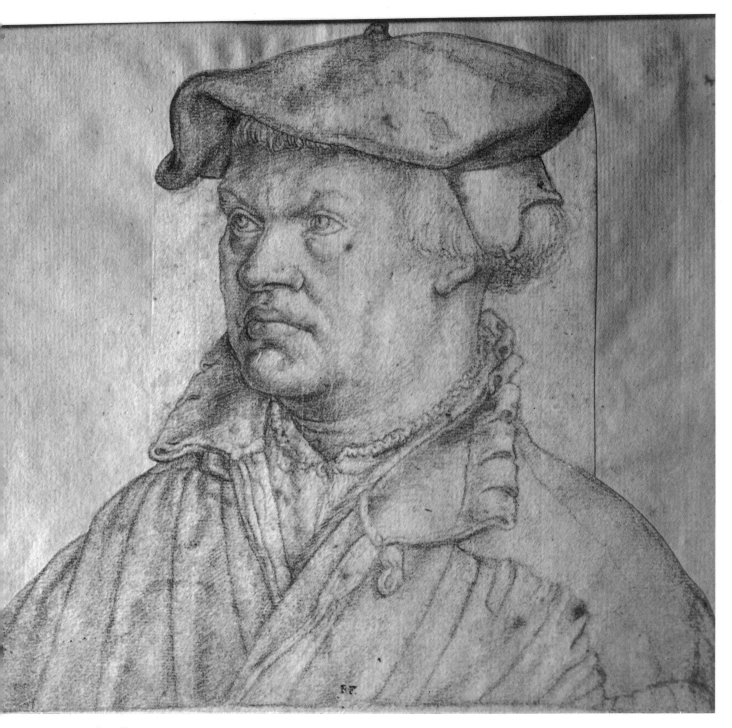

Plate 55
Heinrich ALDEGREVER · *Portrait of a Man in a Flat Hat* · black chalk, slightly touched in red chalk, 184 x 214 mm. · Paris, Louvre

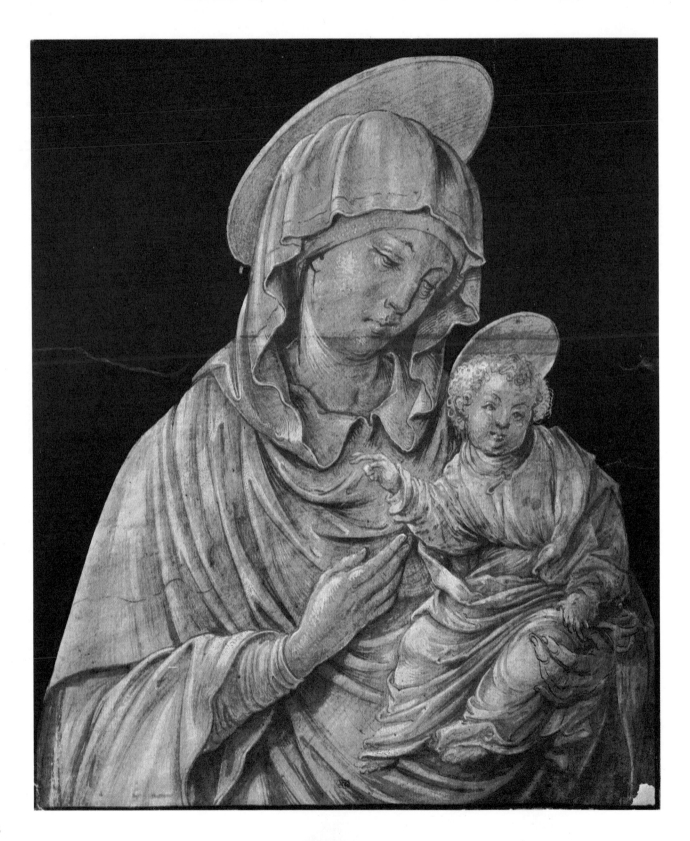

Plate 56
Hans BURGKMAIR the Elder
The Virgin and Child
brush, red chalk diluted in
water, heightened in white
body-color, the background
laid out in India ink
295 x 249 mm.
Paris, Louvre

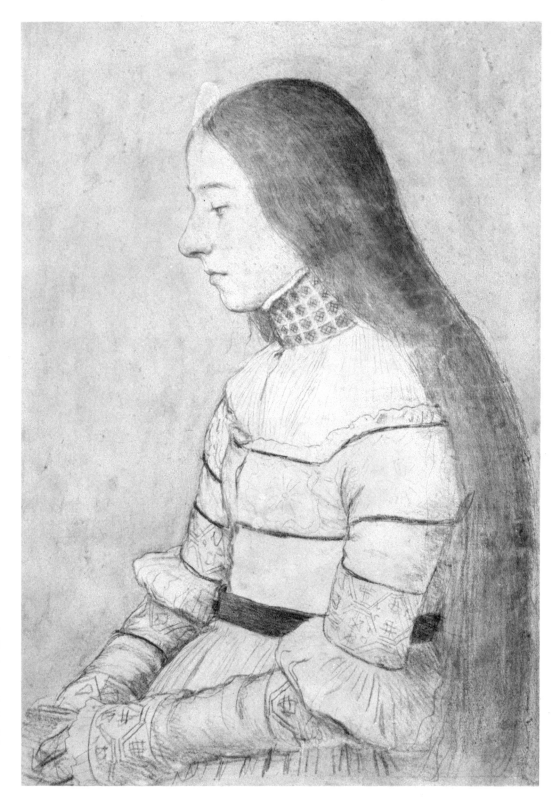

Plate 57
Hans HOLBEIN the Younger
Portrait of Anna, the Daughter
of Jakob Meyer
(in Profile to the Left)
black and colored chalks on
white paper tinged in a
greenish tone, 391 x 275 mm.
Basel, Kupferstichkabinett

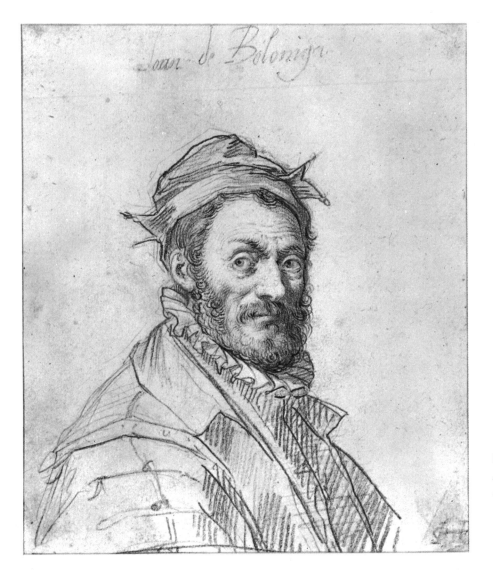

Plate 58
Josef HEINTZ the Elder
Portrait of Giovanni da Bologna
black and red chalks, 148 x 128 mm.
New York, Dr. Julius S. Held

Plate 59
Johann ROTTENHAMMER • *Paris and the Three Graces* • red crayon and brush with bistre, Sacramento (Calif.)
The E. B. Crocker Art Gallery

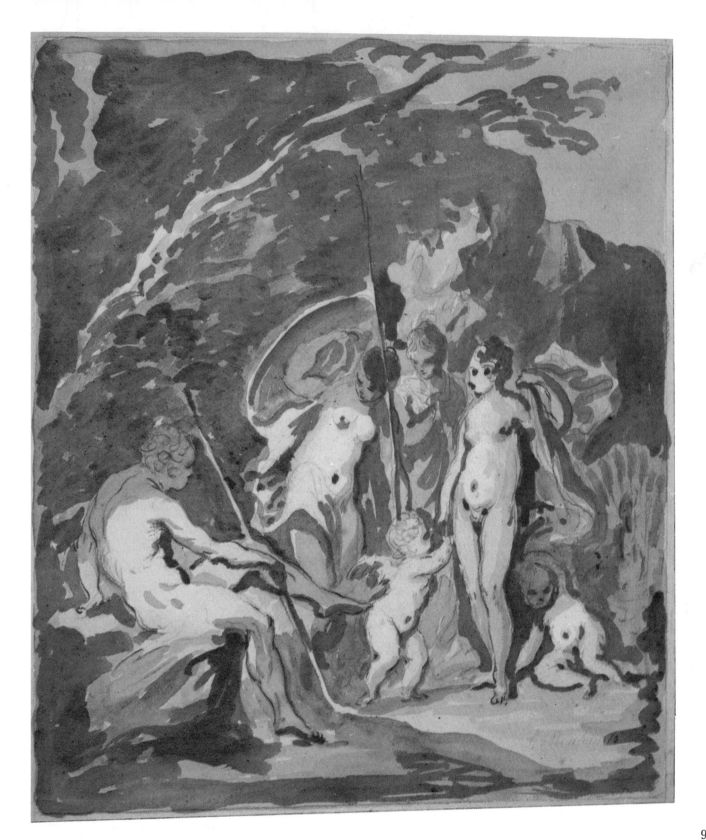

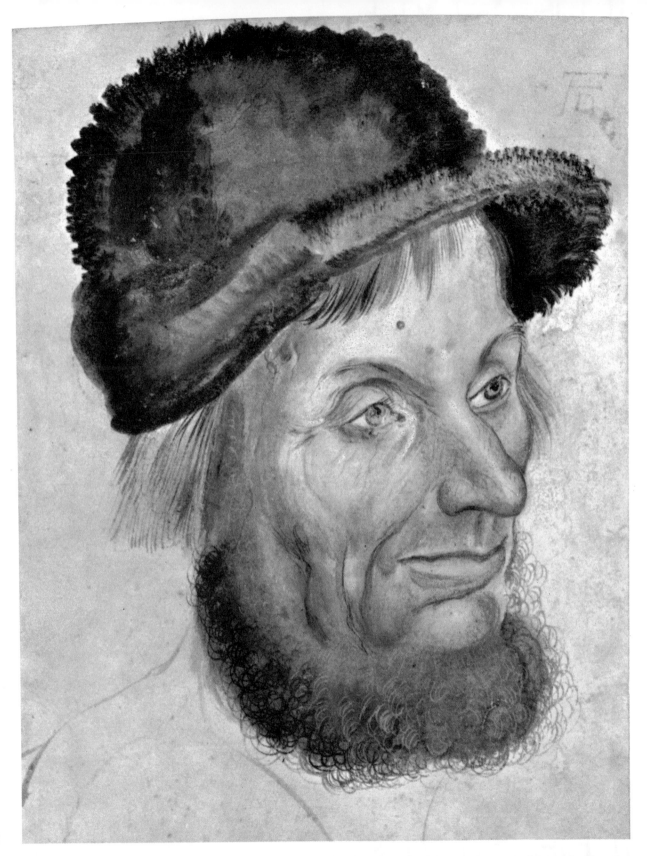

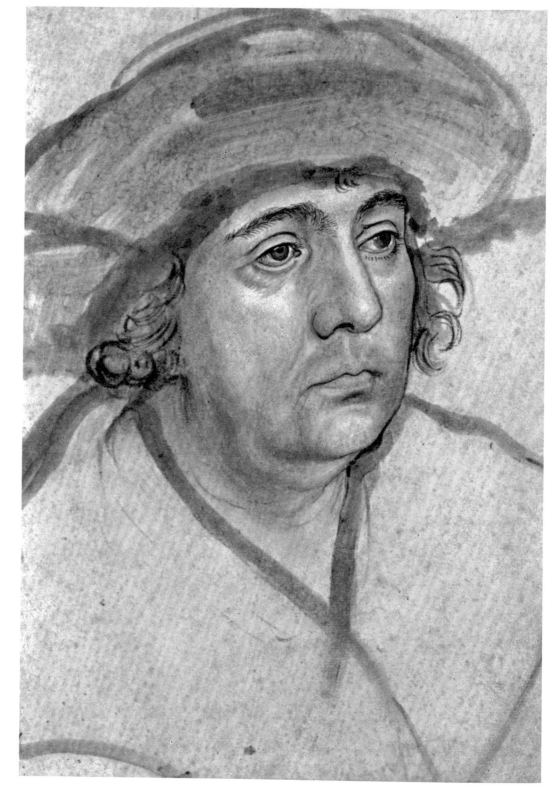

e 60
:as CRANACH the Elder
rtrait of a Man in a
Hat (detail)
ish in water color and
dy-color, 238 x 167 mm.
don, The British Museum

Plate 61
Lucas CRANACH the Elder
Portrait of a Man in a
Wide-Brimmed Hat
brush, water color and
body-color, 264 x 187 mm.
London, The British Museum

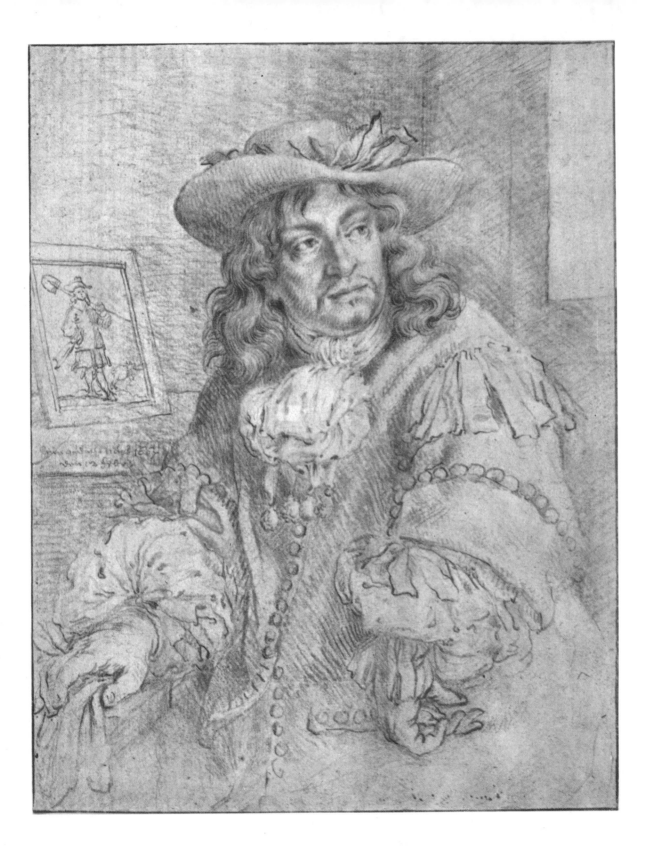

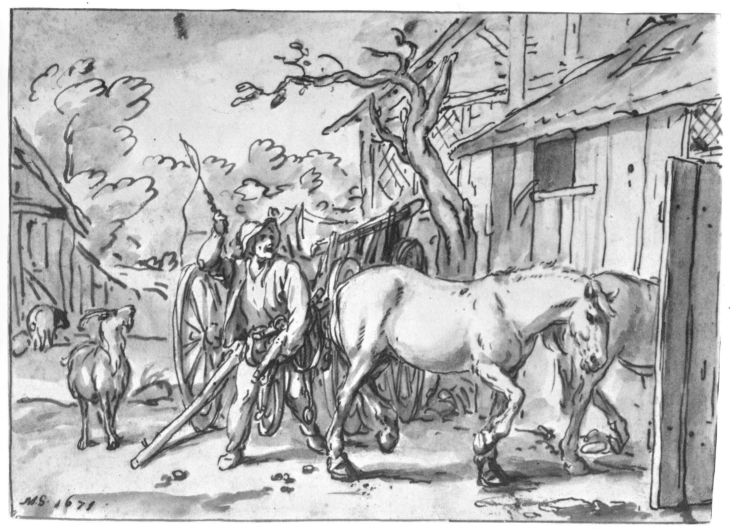

Plate 63
Matthias SCHEITS · *Farmer Driving Horse into the Stall* · bistre drawing with gray India ink, 204 x 293 mm.
Hamburg, Kunsthalle

Plate 62
Georg STRAUCH · *Man Seated before a Small Picture* · sanguine and black pencil, 203 x 160 mm.
Sacramento (Calif.), The E. B. Crocker Art Gallery

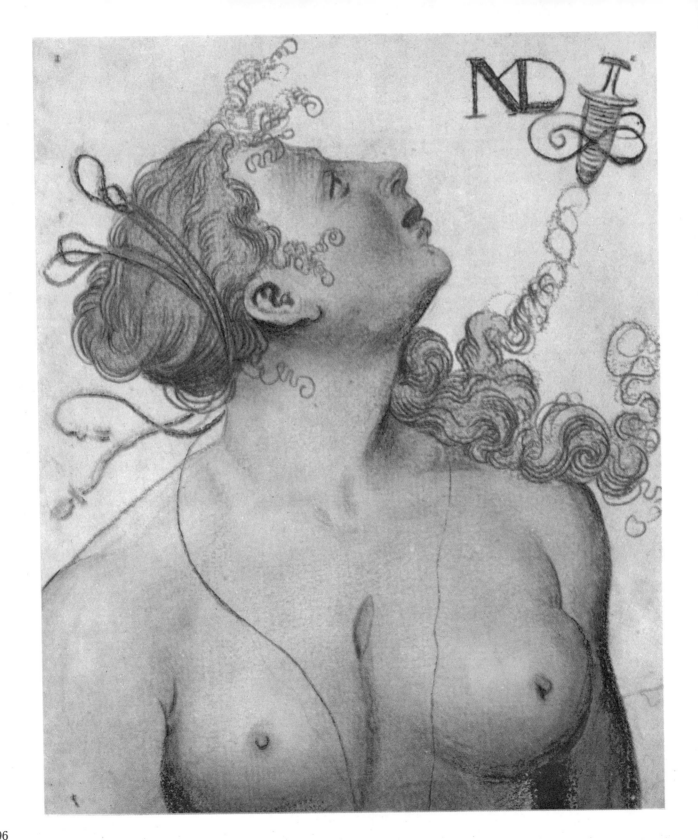

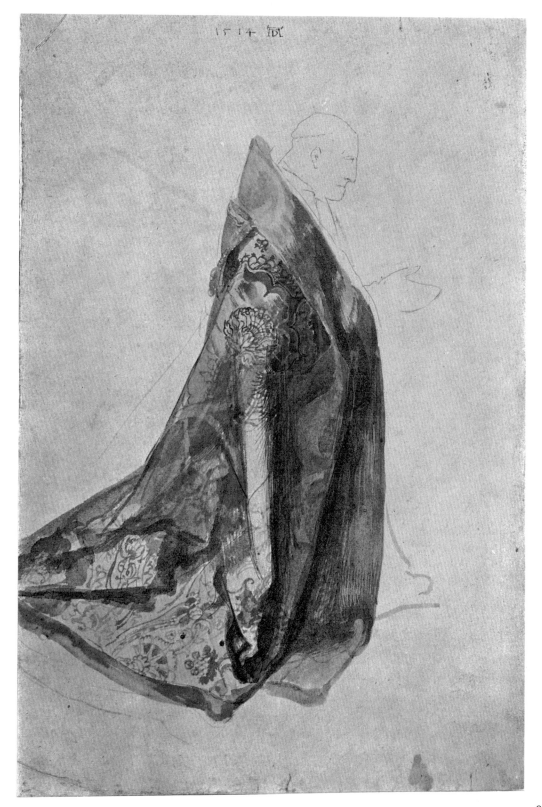

Plate 67
Juriaen JACOBSEN · *The Hunter* · wash drawing, 212 x 282 mm. · Sacramento (Calif.), The E. B. Crocker Art Gallery

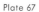

66
...s von AACHEN · *The Baptism of Christ* · black chalk, pen and bistre wash, heightened with white body-color, 292 x 232 mm.
...nbridge, Fitzwilliam Museum. Reproduced by permission of The Syndics of the Fitzwilliam Museum, Cambridge

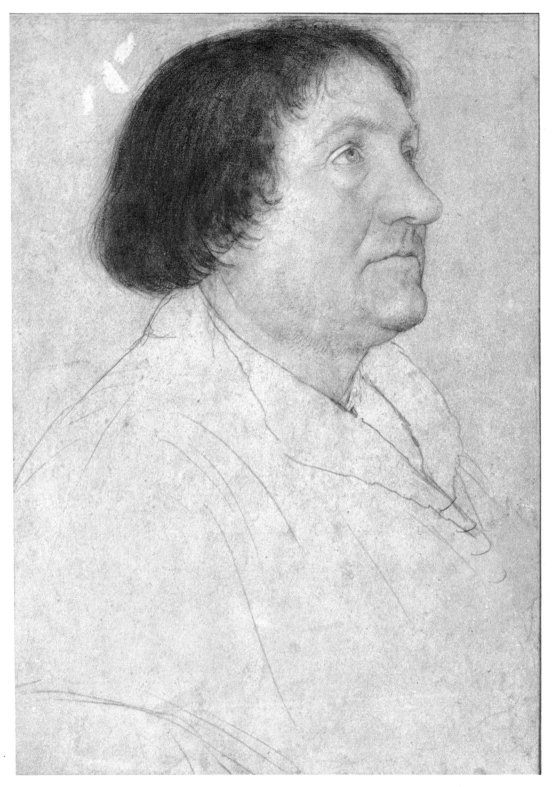

Plate 68
Hans HOLBEIN the Younge[r]
*Portrait of the Mayor
Jakob Meyer* (Bust)
black and colored chalks o[n]
grayish-white paper
383 x 275 mm.
Basel, Kupferstichkabinett

Pl[
Niklaus Manuel DEUT[
The Unequal C[
pen and India ink and pe[r]
brush in pink and [
body-color on red-prep[
paper, 203 x 18[
Basel, Kupferstichka[

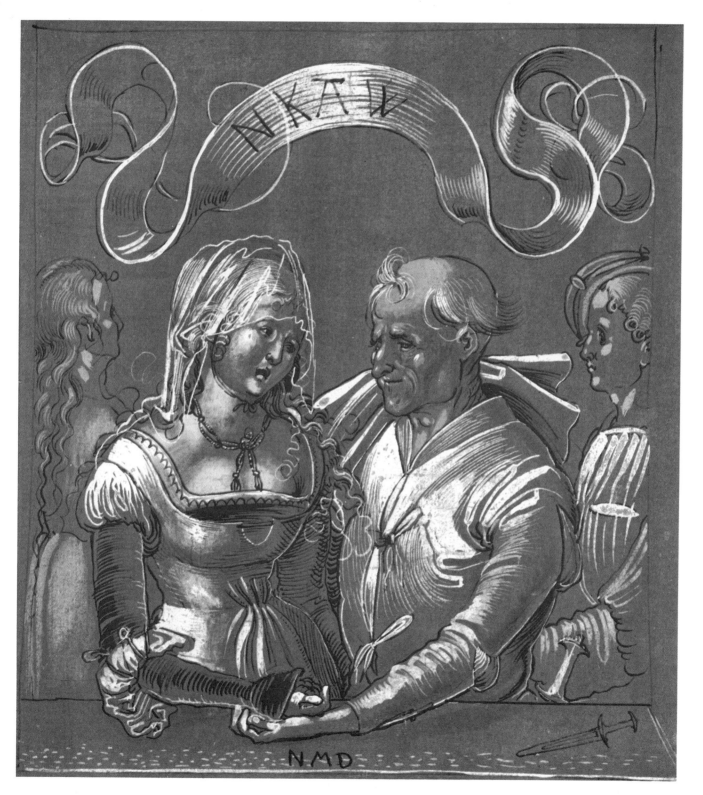

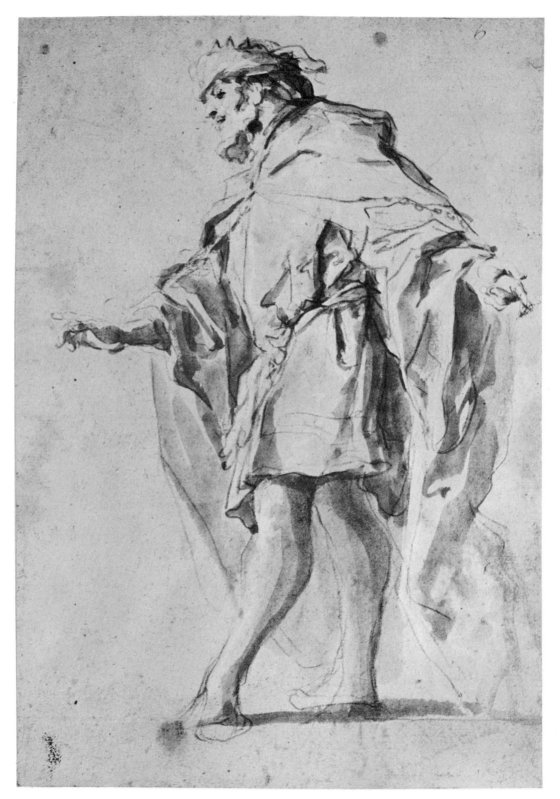

Plate 70
Cosmas Damian ASAM
A King Striding to the Left
red chalk with gray wash
heightened with white
279 x 196 mm.
Munich, Staatliche
Graphische Sammlung

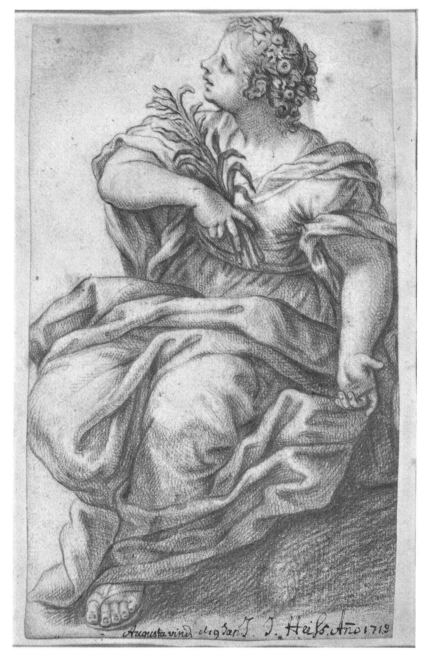

Plate 71

Gottlieb I. HEISS · *Augusta (Augsburg), 1719* · red chalk on cream paper
mounted, 162 x 100 mm. (irregular)
Northampton (Mass.), Smith College Museum of Art

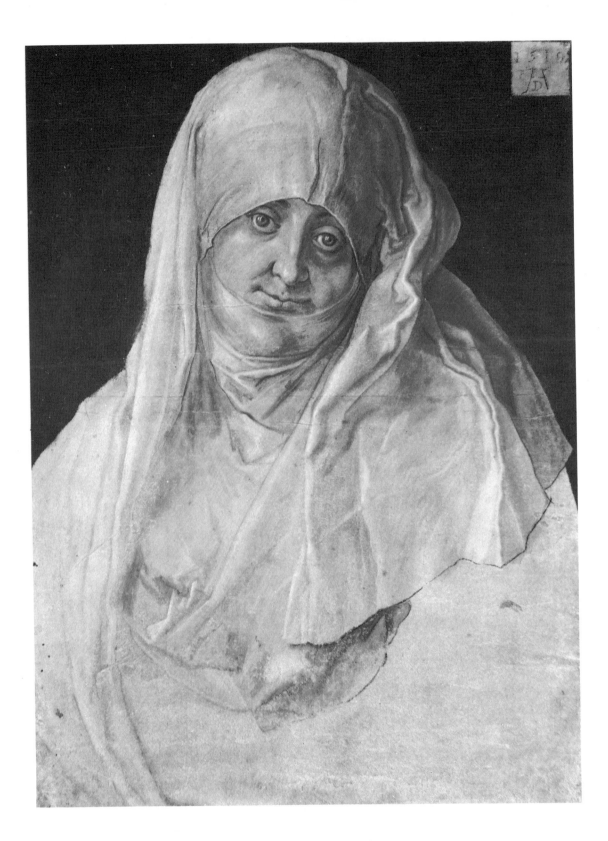

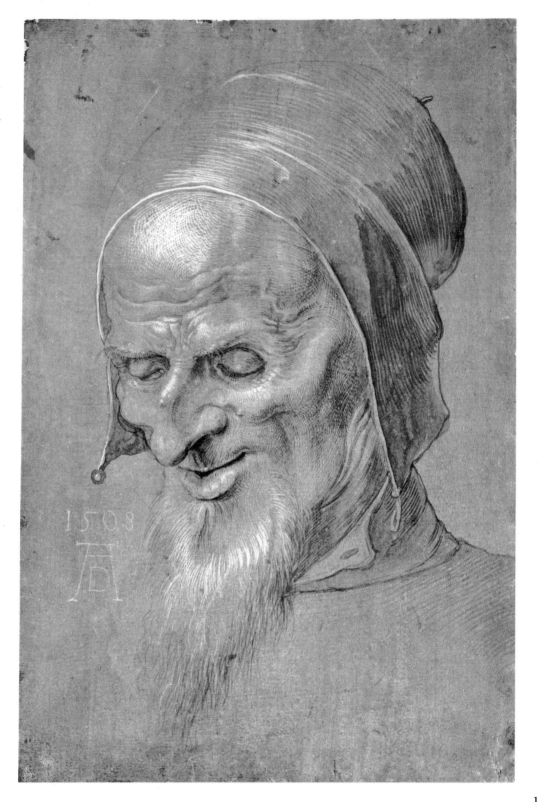

Plate 73
Albrecht DÜRER
Head of an Apostle
brush and India ink and white
body-color on green-prepared
paper, 317 x 212 mm.
Vienna, Albertina Gallery

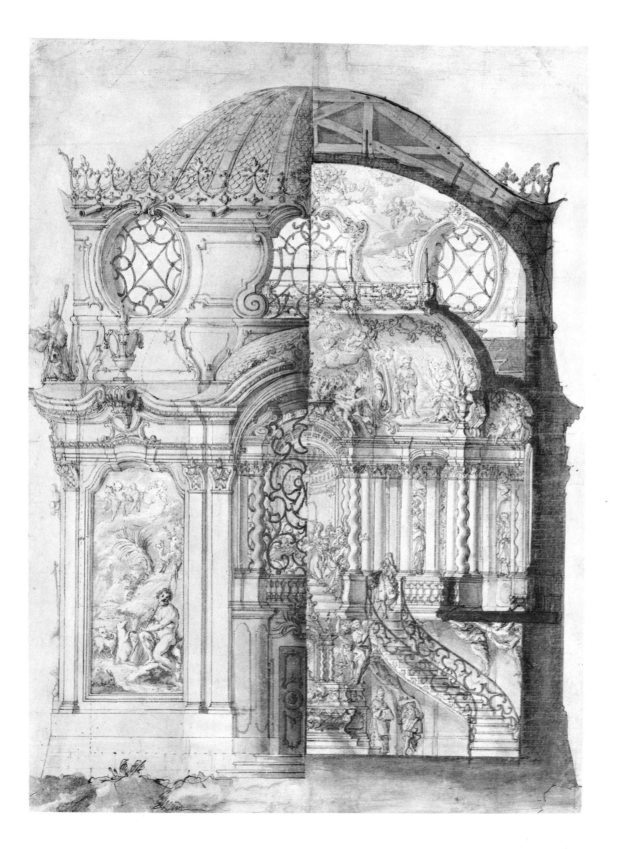

106

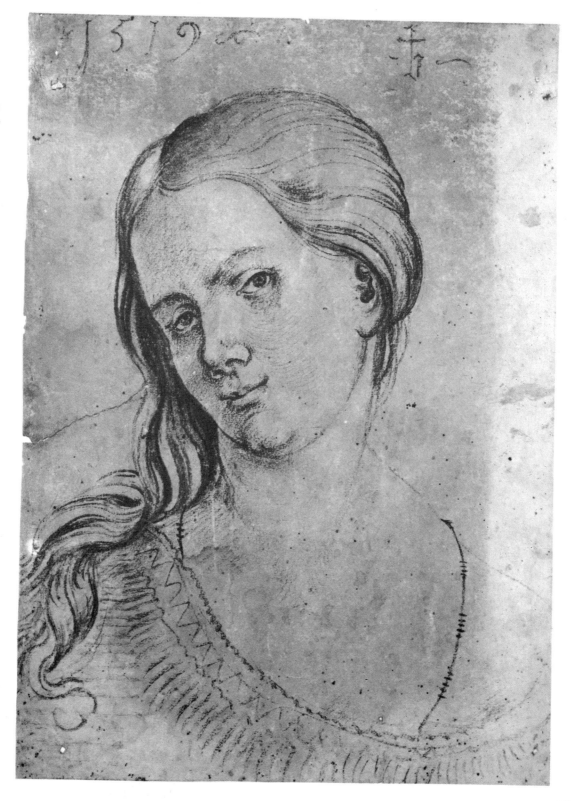

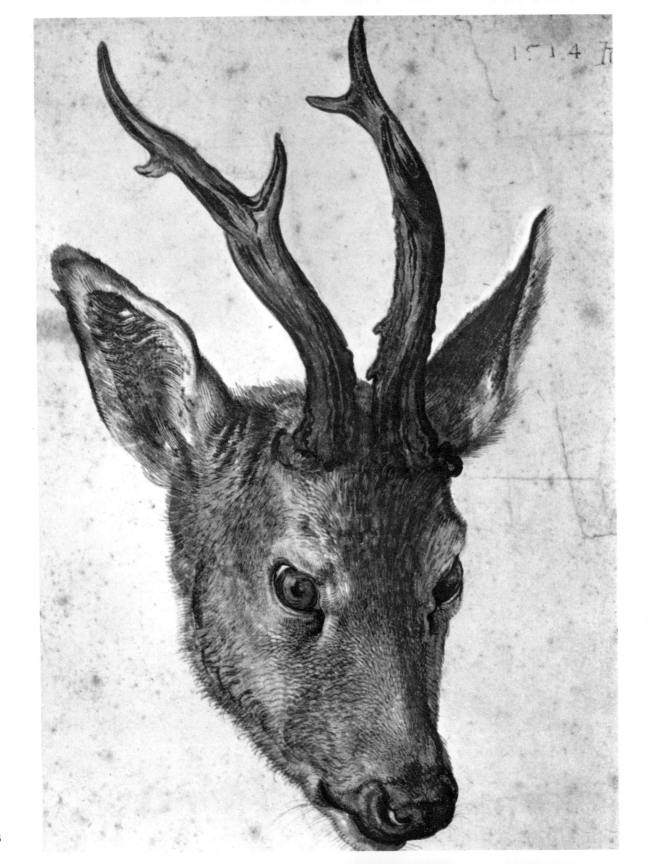

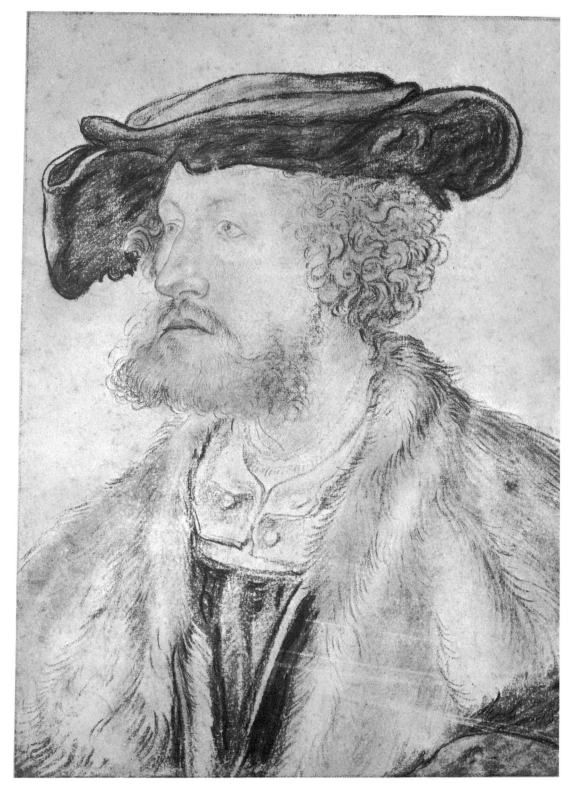

Plate 77
Barthel BEHAM
Portrait of a Bearded Man
in a Flat Cap
black and red chalk, wash
352 x 281 mm.
Berlin, Kupferstichkabinett

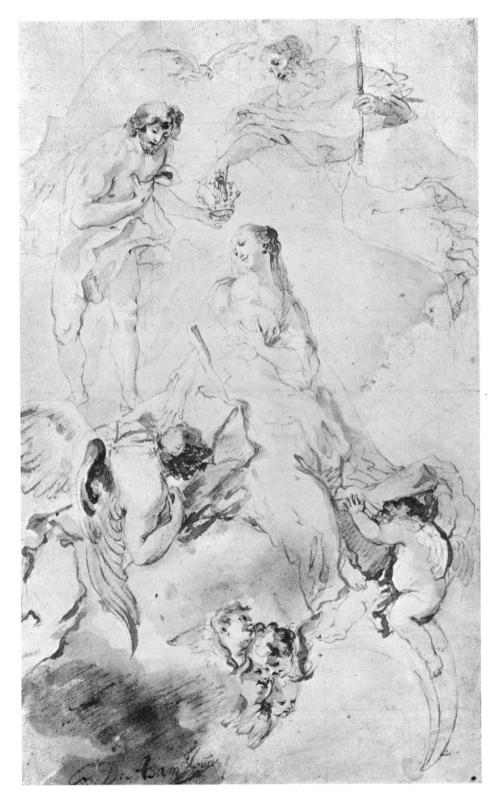

Plate 78

Cosmas Damian ASAM
The Coronation of the Virgin
pencil, pen and brush in bistre
heightened in white, indented for
transfer, 411 x 259 mm.
Vienna, Albertina Gallery

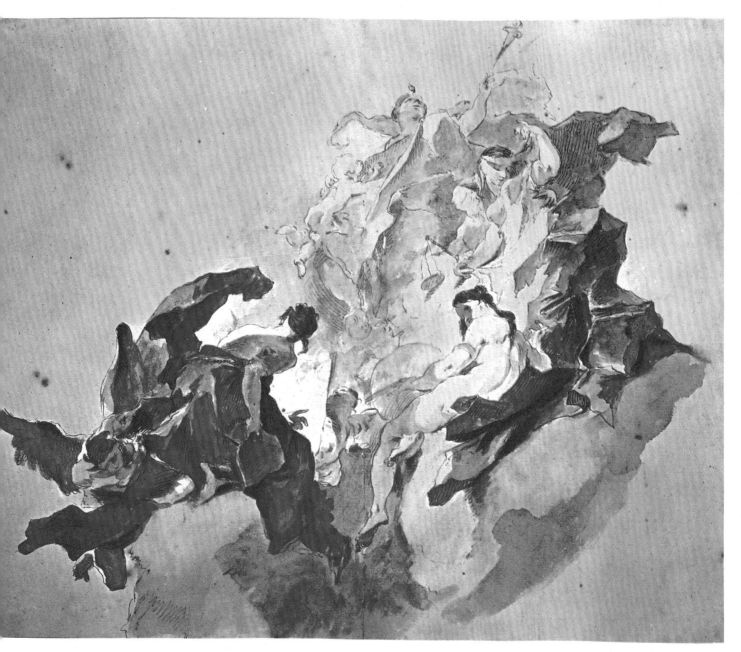

Plate 79

Franz Anton MAULBERTSCH · *Fides, Justitia and Pictura* · pen and bistre, washes in gray and brown, 337 x 419 mm.
Vienna, Albertina Gallery

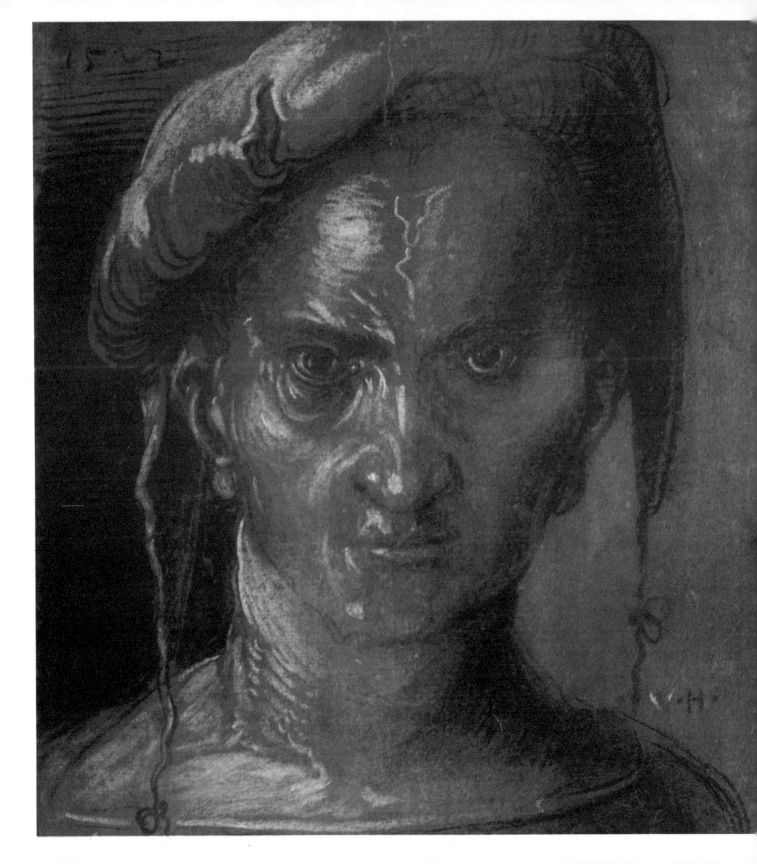

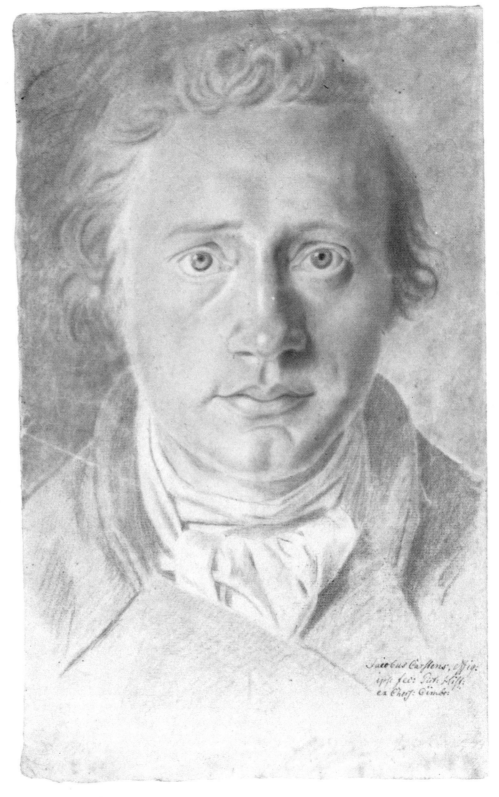

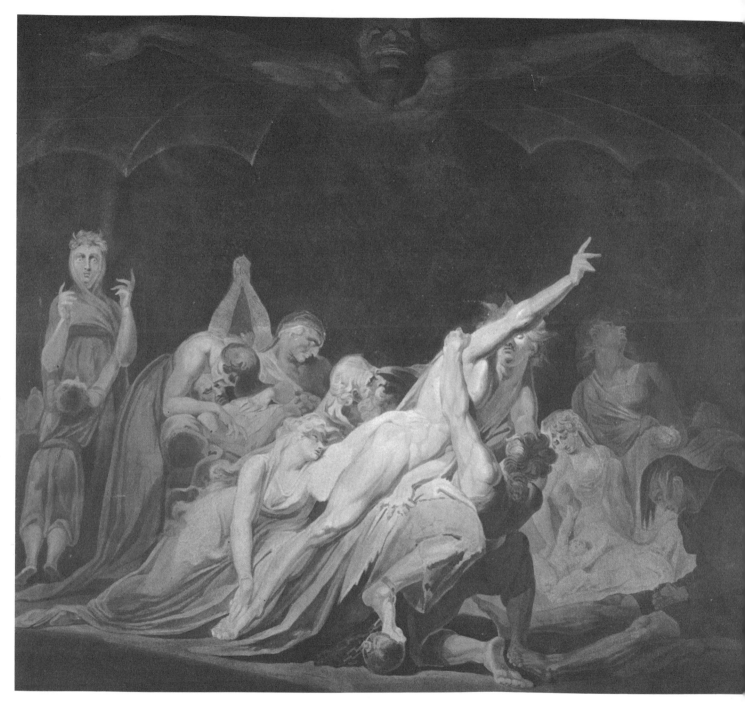

Plate 82

Heinrich FUSELI · *The Passing of the Angel of Death* · brown wash heightened with white, 524 x 604 mm.
Santa Barbara (Calif.), Museum of Art

Plate 83
Philip Hieronymus
BRINCKMANN
The Raising of Lazarus
red chalk and reddish wash
355 x 267 mm.
Munich, Staatliche
Graphische Sammlung

Plate 84

Georg von DILLIS • *View of the Starnberger See and the Bavarian Alps* • pen, pencil and water color, 275 x 355 mm. Munich, Staatliche Graphische Sammlung

Plate 85

Tobias STIMMER • *The Painter and His Muse* • brush and India ink and white body-color on red-prepared paper, 403 x 314 mm. Basel, Kupferstichkabinett

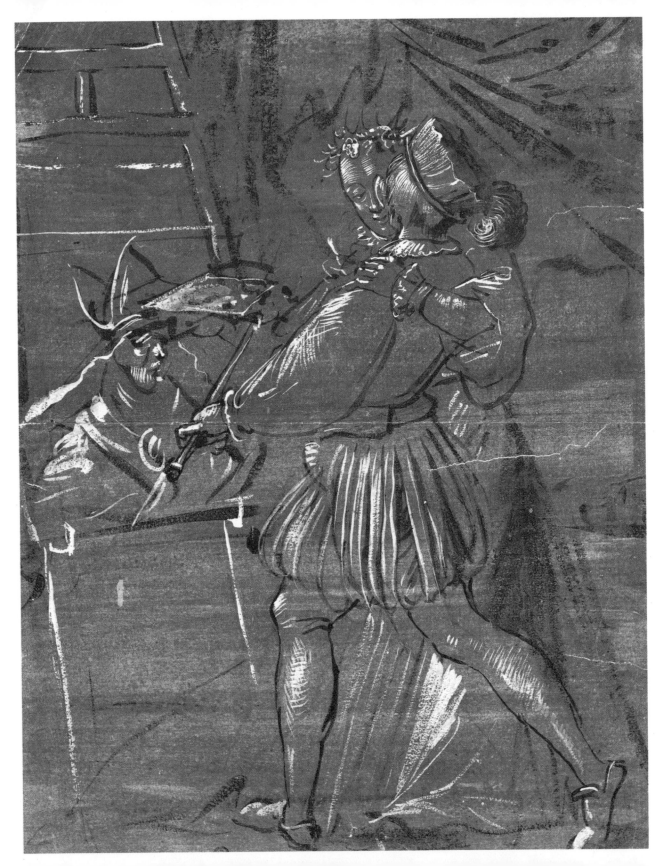

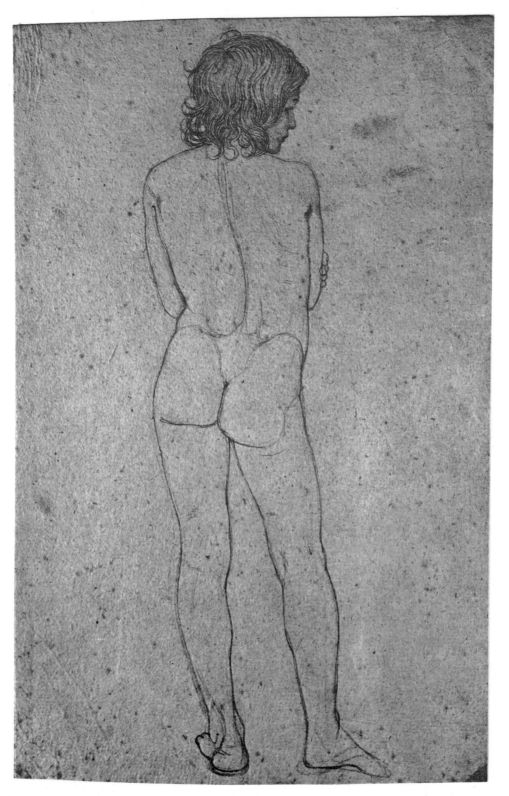

Plate 86
Franz PFORR
Nude Youth
lead pencil on gray paper
283 x 184 mm.
Frankfort-on-Main
Staedel Art Institute

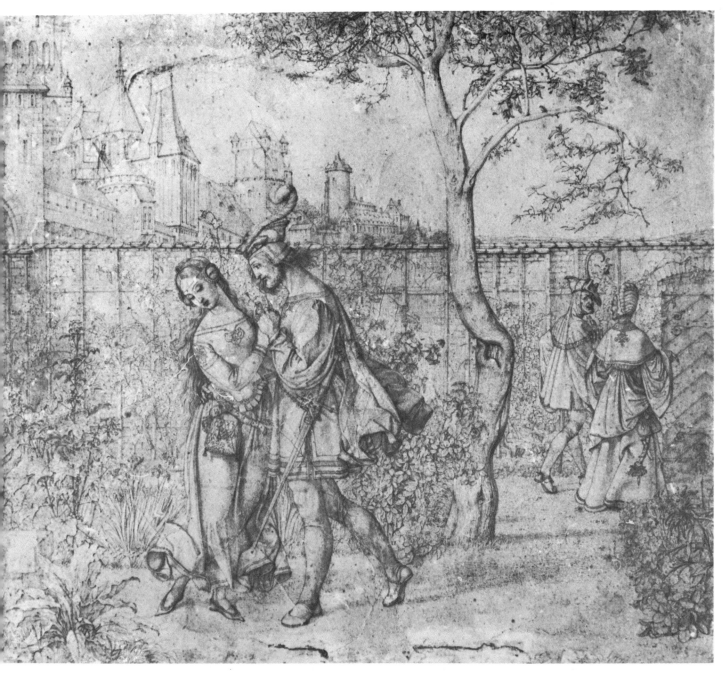

Plate 87

Peter CORNELIUS · *Faust and Gretchen in the Garden* · lead pencil, 349 x 400 mm. · Weimar, Goethe-Nationalmuseum

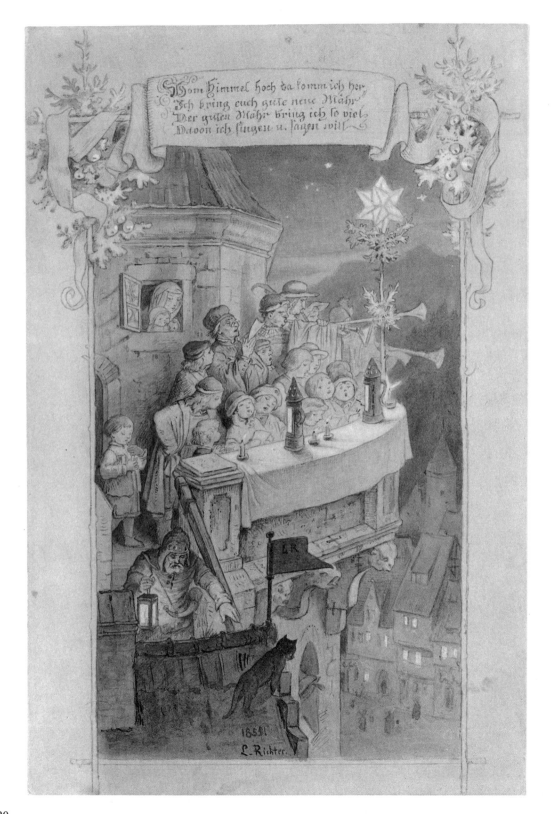

Plate 88
Adrian Ludwig RICHTER
A Christmas Carol
pen, pencil and water color on
buff paper, 256 x 172 mm.
Munich, Staatliche
Graphische Sammlung

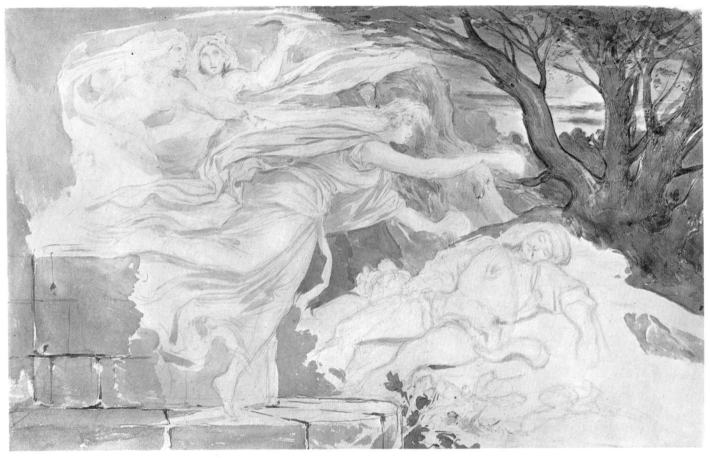

Plate 89
Moritz von SCHWIND · *Sleeping Hunters Approached by Spirits* · pencil and water color, 290 x 470 mm. · Berlin, National Gallery

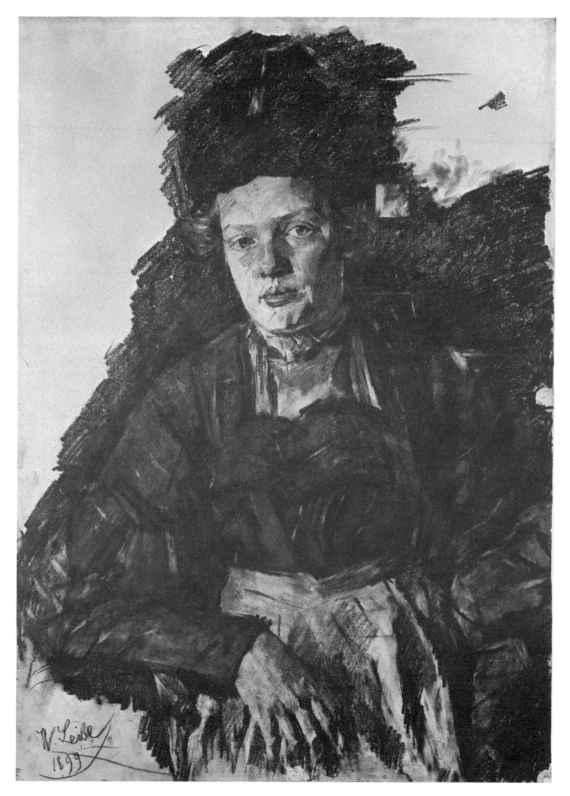

Plate 90

Wilhelm LEIBL
Peasant Girl Wearing a
Fur Hat
charcoal, 626 x 448 mm.
Cologne, Wallraf-Richartz
Museum

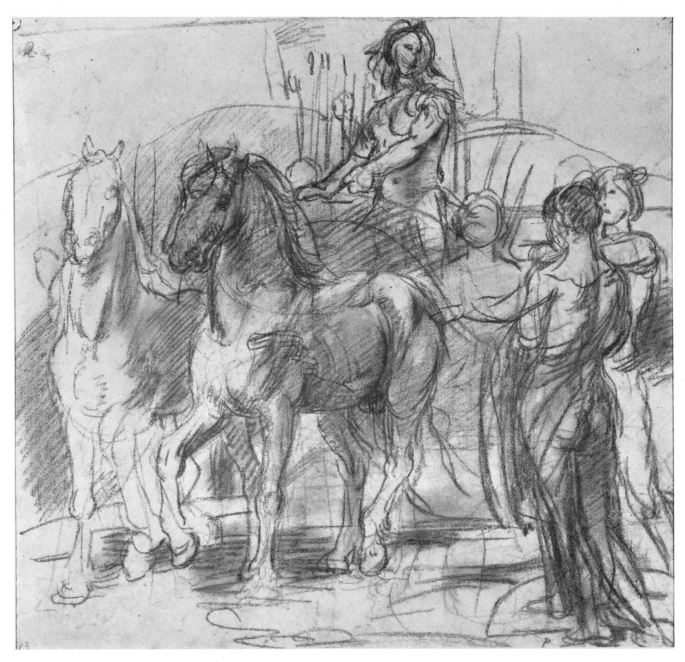

Plate 91

Hans von MAREES • *Ancient Chariot with a Pair of Horses and Several Female Figures* • red chalk, ca. 390 x 405 mm. (irregular)
Munich, Staatliche Graphische Sammlung

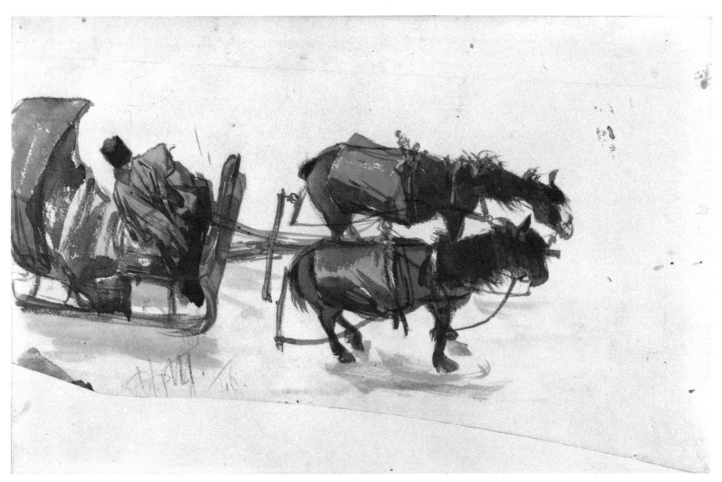

Plate 92
Adolf von MENZEL · *Sledge and Team of Horses* · water color, 168 x 262 mm. · Berlin, National Gallery

Plate 93
Arnold BOCKLIN · *Head of a Triton* · chalk on blue paper, 400 x 302 mm. · Berlin, National Gallery

125

126

Plate 95
Ferdinand OLIVIER · *Landscape of Aigen near Salzburg* · pencil, light brown wash, heightening in white body-color, 138 x 267 mm.
Vienna, Albertina Gallery

Plate 96

Adolf von MENZEL • *Study for Portrait of Princess Amalie of Prussia* • chalk with white heightening, 374 x 300 mm.
Berlin, National Gallery

Biographies

Hans von AACHEN

Hans von Aachen (1552-1615) was born in Cologne. From 1574 to 1588 he was in Venice, Rome and Florence and was active in Munich and Augsburg from 1589 to 1594. Emperor Rudolph II called him to Prague as court painter in 1592 where he remained until his death.

Heinrich ALDEGREVER

Heinrich Aldegrever (1502-ca.1558) was born in Paderborn and active in Soest. He engraved portraits of the Duke of Cleveland and the Anabaptists in Muenster.

Albrecht ALTDORFER

Albrecht Altdorfer (ca. 1480-1538) was born in Ratisbon. He was a pupil of his father, Ulrich Altdorfer. He was commissioned by different abbeys to make prints and altar paintings on his several journeys to Austria in 1505, 1511, and after 1518. Later he worked for Emperor Maximilian I and the Duke of Bavaria. He became councillor and architect of the city of Ratisbon and was the most important engraver and painter in the Danube region.

Cosmas Damian ASAM

Cosmas Damian Asam (1686-1729) was the chief architectural designer of the South German Baroque period. He settled in Munich and was active, with his brother, Egid Quirin, in Bavaria, Bohemia, and the Tyrol.

Egid Quirin ASAM

Egid Quirin Asam (1692-1756) was a stucco worker and sculptor who collaborated with his brother the architect, Cosmas Damian Asam in Baroque palace and church decoration.

Hans BALDUNG called Grien

Hans Baldung called Grien (1484/85-1545) became a pupil of a Strassburg painter about 1500, and perhaps, after 1503, a pupil of Dürer in Nuremberg. He was also court painter to the Bishop and member of the city council of Strassburg. His woodcuts and paintings show the influence of Dürer, but his favorite motif was the female nude, often in gruesome allegorical subjects.

Barthel BEHAM

Barthel Beham (1502-1540) was born in Nuremberg and became a pupil of Dürer. Prosecuted because of religious reasons, he emigrated to Munich in 1525 and was made painter to the court of Bavaria. He died in Italy.

Arnold BOCKLIN

Arnold Böcklin (1827-1901) was a Swiss painter of imaginative scenes, particularly landscapes, who was inspired by German and Greek idealism.

Joerg BREU the Elder

Joerg Breu (1474/80-1537) was born in Augsburg. He was active in Austria in 1500-'02 and also worked in Augsburg.

Philipp Hieronymous BRINCKMANN

Philipp Hieronymous Brinckmann (1709-1761) was a German painter and engraver of landscapes and historical subjects. In his portraits he was influenced by the style and color of Rembrandt.

Hans BURGKMAIR the Elder

Hans Burgkmair the Elder, the son and pupil of the painter Thomas Burgkmair, was born in Augsburg. He became a pupil of Martin Schöngauer in Colmar. He traveled to the Lower Rhine and Venice and worked in Augsburg.

Asmus Jakob CARSTENS

Asmus Jakob Carstens (1754-1798) exerted an important influence on 19th-century German painting in advocacy of the return to the study of antiquity and the idealization of subject matter. His water colors are especially valued in this century.

Peter von CORNELIUS

Peter von Cornelius (1783-1867) went to Rome in 1811 and worked with the Nazarene group of German painters of Renaissance-Revival pictures. Returning to Munich in 1819, he became the head of a school of monumental fresco painting featuring Romantic and literary subjects.

Lucas CRANACH the Elder

Lucas Cranach the Elder (1472-1533), chiefly remembered for his portraits and allegorical paintings, was born in Franconia and was active in Vienna about 1500-04. In Wittenberg he was court painter to Elector Frederick the Wise of Saxony and a friend of Martin Luther.

Niklaus Manuel DEUTSCH

Niklaus Manuel Deutsch (1484-1530) was a printer, draughtsman, and poet who became a member of the guild in 1512. He died in Berne.

Georg von DILLIS

Georg von Dillis (1759-1841) was a landscape painter, draughtsman, engraver, and a Catholic priest who accompanied the Bavarian Crown Prince, who became Ludwig I, on his travels. He was the first director of the Bavarian art collections and first Professor of Landscape in Munich.

Albrecht DURER

Albrecht Dürer (1471-1528) was born in Nuremberg where he was a pupil of his father and of Michael Wolgemut. From 1490-'94 he worked in Basel, Colmar, and Strassburg. He journeyed to Venice, 1495-'96 and 1505-'07, and to the Netherlands, 1520-'21. His prolific drawings, engravings, and woodcuts are of greatest importance in the history of art. There are also many water colors and gouache landscapes and fewer paintings among the works of this great German Renaissance artist.

The Master E.S.

The Master E.S. (active 1440-1470) was the chief German engraver before Martin Schöngauer, working in the region of Lake Constance and the Upper Rhine.

Henry FUSELI

Henry Füseli (1741-1825) was a Swiss artist (Johann Heinrich Füssli) who left Zurich and went to London where he was influenced by William Blake and illustrated world literature. His figure compositions are identified by exaggerated gestures and a preference for phantom subjects.

Urs GRAF

Urs Graf (ca. 1485-1528) was a Swiss goldsmith, draughtsman and engraver. He traveled frequently, mainly to Strassburg and settled at Basel in 1509. He participated in military expeditions of Swiss mercenaries to Italy and Burgundy, and many of his drawings were based on the scenes of that rough life. His only painting was entitled *War*.

Matthias GRUNEWALD

Matthis Gothart Nithart called Matthias Grünewald (1475/80-1527) was active as court painter to the Archbishop of Mainz in Aschaffenburg, Frankfort, and Mainz. Unlike his contemporaries, Grunewald made no engravings and few drawings have survived except for the Isenheim altarpiece in Alsace. He was a hydraulic engineer in the service of the city of Halle in 1527.

Josef HEINTZ the Elder

Josef Heintz the Elder (1564-1609) a Swiss painter and architect, was the son of the architect and sculptor, Daniell Heintz, and was strongly influenced by Hans Holbein the Younger for whom he worked in Basel from 1581-'83.

Gottlieb I. HEISS

Gottlieb I. Heiss (1684-1740) was an Augsburg court painter and draughtsman.

Hans HOLBEIN the Elder

Hans Holbein the Elder (1460/70-1524) was born at Augsburg. He studied at Ulm and in the Netherlands and returned to his native city in 1494. His sons were Ambrosius and Hans Holbein the Younger, the latter outstripping his fame. The Elder painted for many Churches and abbeys in Southern Germany and also for the Dominicans at Frankfort.

Hans HOLBEIN the Younger

Hans Holbein the Younger (1497-1543), one of the greatest portrait painters, was born at Augsburg, the son and pupil of Hans Holbein the Elder. He settled at Basel and went to Lucerne and probably to Italy and visited France. He made his first journey to England in 1526 but went back to Basel in 1528. After 1532 he returned to England where he died of the plague.

The Master of the HOUSEBOOK

The Master of the Housebook (active 1475-1500) was so-called after the illustrated manuscript of the Hausbuch in the Castle of Wolfegg in Allgaeu. After Schöngauer, he was the most important painter-engraver and draughtsman active in the last quarter of the 15th century on the Middle Rhine.

Wolf HUBER

Wolf Huber (ca. 1485-1553) worked probably in the shop of Joerg Koelderer at Innsbruck about 1510 and settled at Passau as court painter to the Bishop. After Altdorfer, he was the most important painter and woodcut designer of the Danube region in which landscape painting made important developments.

Juriaen JACOBSEN

Juriaen Jacobsen (1625-1685) was a German painter and engraver who studied in the school of Frans Snyders at Antwerp and travelled a great deal, especially in Switzerland. He was particularly known for his animal paintings.

Hans Suess von KULMBACH

Hans Suess von Kulmbach (ca. 1480-1522) studied in Nuremberg, first with Jacopo de Barbari, then with Dürer and, along with Schaeuffelein, became one of Dürer's chief followers. He was also influenced by Venetian painting and worked in Cracow from 1514-'16.

Wilhelm LEIBL

Wilhelm Leibl (1844-1900) was born in Cologne and painted Bavarian villagers and peasants. His works have been admired for their extraordinary attention to detail and for his fine portraits. His early work was influenced by Courbet.

Hans LEU the Younger

Hans Leu the Younger (ca. 1490-1531) was born in Zurich. He became a pupil of Dürer in Nuremberg and of Baldung in Freiburg im Breisgau. In 1514 he settled in Zurich and was killed in battle.

Stephan LOCHNER

Stephan Lochner (ca. 1400-1451) settled in Cologne, where he is mentioned in documents after 1442. He was one of the major Late-Gothic painters.

Hans von MAREES

Hans von Marées (1837-1887) studied at the Academy in Berlin and first settled at Munich in 1857. He travelled extensively through Europe. In 1873 he painted frescoes in Naples and in 1874 moved to Rome, where he died in 1887. He brought new forcefulness and vitality into 19th-century German drawing and painting.

Franz Anton MAULBERTSCH

Franz Anton Maulbertsch (1724-1796) was a fresco painter who was born near the Lake of Constance. A pupil at the Academy of Vienna, of which he became a member in 1759 and councillor in 1770, he worked mainly in Austria, Hungary, Moravia, and Bohemia and died in 1796 in Vienna.

Adolf von MENZEL

Adolf von Menzel (1815-1905) was Germany's greatest Realist painter, who, in later years, developed into an Impressionist. He is now best known for his drawings, historical paintings, woodcuts and genre subjects.

Ferdinand OLIVIER

Ferdinand Olivier (1785-1841) was a German painter, born at Dessau. He met Caspar David Friedrich in Dresden. In 1811 he settled in Vienna, and moved in 1830 to Munich.

Franz PFORR

Franz Pforr (1788-1812) was a German historical painter whose subjects were taken almost exclusively from scripture and German legends.

Adriaen Ludwig RICHTER

Adriaen Ludwig Richter (1803-1884) was a German painter and engraver noted for his humorous and poetic illustrations for German fairy tales and folksong. Believing that all true art must have its roots in the soil that produces the artist, he used the German landscape as the vehicle for all his work.

Herman tom RING

Herman tom Ring (1521-1596) was a member of an important Westphalian family of painters in Munster. He was the eldest son of Ludgers tom Ring and spent a year studying with Flemish artists in the Netherlands. He also went to England and to see the paintings done there by Hans Holbein the Younger.

Johann ROTTENHAMMER the Elder

Johann (Hans) Rottenhammer the Elder (1564-1622/25) was born in Munich and painted mainly in Germany although he was in touch with the Flemish artists, Paul Brill, (who worked in Rome) and Jan Brueghel. In Venice he admired the paintings of Tintoretto, Veronese and Palma Giovane.

Hans Leonhard SCHAEUFELEIN

Hans Leonhard Schaeufelein (ca. 1480-1538/40) was born in Nuremberg and became a pupil of Dürer, 1503-'08. He traveled to the Tyrol and was active in Augsburg and elsewhere in Swabia after 1510. From 1515 on, he was active in Noerdlingen.

Matthias SCHEITS

Matthias Scheits (1630/45-1700), a German painter, was a follower of Philips Wouwerman and later, of David Teniers. He designed series of scriptural illustrations and was noted for a bold, free style.

Martin SCHONGAUER

Martin Schongauer (ca. 1430-1491) the chief German engraver of his time, was born at Colmar, the son of the goldsmith Caspar Schongauer. In 1491 he died at Breisach, where he had painted frescoes in the cathedral.

Moritz von SCHWIND

Moritz von Schwind (1804-1871) was a Viennese painter and draughtsman who lived in Munich. Most of his subjects were based on history and fairy tales; full of imagination and humor. He also illustrated many books.

Hans SPRINGINKLEE

Hans Springinklee (d. ca. 1540) was a pupil of Dürer and was an illuminator in Constance in 1511. Active in Nuremberg 1512-'22, he was one of Dürer's collaborators in his commissions for Emperor Maximilian I.

Tobias STIMMER

Tobias Stimmer (1539-1584), a painter and engraver, was born at Schaffhausen. After an apprenticeship in Zurich and perhaps in Italy, he returned to his native city in 1560. He settled in Strassburg in 1570 and became a member of the guild in 1582.

Veit STOSS

Veit Stoss (1447-1533), a sculptor, engraver and painter, was born in Dinkelsbuehl or Nuremberg. He worked in Cracow from 1477 and settled in Nuremberg in 1496.

Georg STRAUCH

Georg Strauch (1613-1675) was a painter, enamelist, engraver, etcher and draughtsman who lived and worked in Nuremberg.

Bernhard STRIGEL

Bernhard Strigel (ca. 1460-1528) was born at Memmingen, the son and later pupil of Ivo Strigel. After several journeys to Austria on commissions for Emperor Maximilian I, he was active mainly in Memmingen where he became councillor of the city.

Konrad WITZ

Konrad Witz (1400/10-1445), one of the most important Late-Gothic painters, was born in Wuerttemberg. In 1434 he became a member of the Basel guild and worked for the Bishop of Geneva in 1444. He died at Basel.

Bibliography

GENERAL

Fisher, O., *Geschichte der deutschen Zeichnung und Graphik.* Munich, 1951.

Möhle, H., *Deutsche Zeichnungen des 17. und 18. Jahrhunderts.* Berlin, 1947.

Parker, K. T., *Drawings of the Early German Schools.* London, 1926.

Schilling, E. (ed.), *Altdeutsche Meisterzeichnungen.* Frankfurt, 1934.

Schilling, E., *Deutsche Romantiker-Zeichnungen.* Frankfurt, 1935.

Schneider, A., *Deutsche Romantiker-Zeichnungen.* Munich, 1942.

Winkler, F., *Altdeutsche Zeichnungen.* Berlin, 1947.

Winzinger, F., *Deutsche Meisterzeichnungen der Gotik.* Munich, 1947.

ALDEGREVER

Fritz, R., *Heinrich Aldegrever als Maler.* Dortmund, 1958.

Geisberg, M., *Heinrich Aldegrever.* Dortmund, 1939.

ALTDORFER

Becker, H. L., *Die Handzeichnungen Albrecht Altdorfers.* Munich, 1938.

Winzinger, F., *Albrecht Altdorfer Zeichnungen.* Munich, 1952.

Cosmas Damian ASAM and Egid Quirin ASAM

Hanfstaengl, E., *Die Brüder Cosmas Damian und Egid Quirin Asam.* Munich, 1955.

BALDUNG GRIEN

Koch, C., *Die Zeichnungen Hans Baldung Griens.* Berlin, 1941.

BÖCKLIN

Bryber-Bender, M., *Arnold Böcklin's Stellung zum Portrait.* Basel, 1952.

BURGKMAIR

Burkhart, A., *Hans Burgkmair d. A.* Leipzig, 1934.

CARSTENS

Kamphausen, A., *Asmus Jakob Carstens.* Neumünster in Holstein, 1941.

CRANACH

Descargues, P., *Cranach,* New York, 1962.

Friedlaender, M. J. and Rosenberg, J., *Die Gemälde von Lucas Cranach.* Berlin, 1932.

Rosenberg, J., *Die Zeichnungen Lucas Cranachs d. A.* Berlin, 1960.

Zervos, C., *Nus de Lucas Cranach l'ancien.* Paris, 1950.

DEUTSCH

Baud-Bovey, D., *Nicolas Manuel.* Genev 1941.

Koegler, H., *Beschreibendes Verzeichr der Basler Handzeichnungen des N laus Manuel Deutsch.* Basel, 1930.

DÜRER

Brion, M., *Dürer.* Paris and London, 196

Panofsky, E., *The Life and Art of Albrec Dürer.* Princeton, 1962.

Tietze, H., and Tietze-Conrat, E., *K tisches Verzeichnis der Werke Albrec Dürers* (3 vols.), Basel and Leipzig, 193 38.

Winkler, F., *Die Zeichnungen Albrec Dürers* (4 vols.). Berlin, 1936-39.

ELSHEIMER

Weizaecker, H., *Adam Elsheimer.* Berli 1936.

FRIEDRICH

Bauer, W., *Bildnis von Caspar Dav Friedrich.* Mainz, 1936.

FUSELI

Jaloux, E., *Johan-Heinrich Fuseli.* Mo treux, 1942.

GRAF

Major, E., and Gradmann, E., *Urs Gra* London, 1947.

GRÜNEWALD

Behling, L., *Die Handzeichnungen des Mathis Gothart Nithart genannt Grünewald*. Weimar, 1955.

Burchard, A., *Matthias Grünewald*. Cambridge (Mass.), 1936.

Pevsner, N., and Meier, M., *Grünewald*. New York, 1962.

Schoenberger, G., *The Drawings of Mathis Gothart Nithart called Grünewald*. New York, 1948.

Zülch, W. K., *Der historische Grünewald*. Munich, 1938.

HOLBEIN

Ganz, P., *Die Handzeichnungen Hans Holbeins d. J.* (1 vol. and 8 portfolios), Berlin, 1937.

Parker, K. T., *The Drawings of Hans Holbein...at Windsor Castle*. London and New York, 1945.

Schilling, E., *Drawings of the Holbein Family*. London, 1937.

HUBER

Weinberger, M., *Wolfgang Huber*. Leipzig, 1930.

KULMBACH

Winkler, F., *Die Zeichnungen Hans Suess von Kulmbachs und Hans Leonhard Schaeufeleins*. Berlin, 1942.

LEIBL

Langer, A., *Wilhelm Leibl*. Leipzig, 1961.

Sailer, A., *Leibl; ein Maler- und Jägerleben*. Munich, 1959.

LISS

Steinbart, K., *Johann Liss*. Berlin, 1940.

LOCHNER

Bombe, W., *Stefan Lochner*. Berlin, 1937.

Helmut, O., *Stefan Lochner; ein Maler zu Köln*. Bonn, 1952.

MAREES

Degenhart, B., *Hans von Marées: Die Fresken in Neapel*. Munich, 1958.

MAULBERTSCH

Ganas, K., *Franz Anton Maulbertsch*. Vienna, 1960.

MENZEL

Waldmann, E., *Der Maler Adolph Menzel*. Vienna, 1941.

OLIVIER

Grote, L., *Die Brüder Olivier und die deutsche Romantik*. Berlin, 1938.

RING

Riewerts, T., *Die Maler tom Ring*. Munich, 1955.

RUNGE

Berefelt, G., *Philipp Otto Runge*. Uppsala, 1961.

SCHADOW

Nemitz, F., *Gottfried Schadow der Zeichner*. Berlin, 1938.

Mackowsky, H., *Die Bildwerke Gottfried Schadows*. Berlin, 1951.

SCHAEUFELEIN

Wallach, H., *Die Stilentwicklung Hans Leonhard Schaeufeleins*. Munich, 1929.

Winkler, F., *Die Zeichnungen Hans Suess von Kulmbachs und Hans Leonhard Schaeufeleins*. Berlin, 1942.

SCHONGAUER

Baum, I., *Martin Schongauer*. Vienna, 1948.

Buchner, E., *Martin Schongauer als Maler*. Berlin, 1941.

SCHWIND

Kalkschmidt, E., *Moritz von Schwind, der Mann und das Werk*. Munich, 1943.

STIMMER

Thöne, F., *Tobias Stimmer Handzeichnungen*. Freiburg im Breisgau, 1936.

STOSS

Hotzel, C., *Tat und Traum des Bildschnitzers Veit Stoss*. Berlin, 1960.

Lutze, E., *Veit Stoss*. Munich, 1952.

WITZ

Schmidt, G., *Conrad Witz*. Geneva, 1947.

Ueberwasser, W., *Konrad Witz*. Basel, 1938.